IMAGES
of America

THE PALISADES
of WASHINGTON, D.C.

DEDICATION

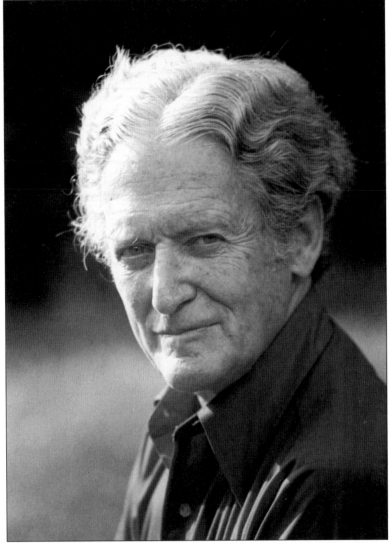

HAROLD GRAY. It is my greatest pleasure to dedicate this book to my friend and mentor, Harold Gray. Harold wrote the history of the neighborhood in 1956, on the 40th anniversary of the Palisades Citizens Association, basing it largely on interviews with people who had grown up here, when the scene was decidedly bucolic. His history was updated and published in 1966. Since then, Harold has written many articles about Palisades history. This book adds pictures to his stories, bringing our history up to the present. While Harold's writing started me on the joyous quest of getting to know this neighborhood, having gotten to know him is an equal joy. Harold was born in 1907, was raised in a small town in rural Missouri, and moved to the Palisades in 1948. Over the next half century, he built an admirable record of public service. Harold loves this city, and to this day he has never lost the boyish awe and enjoyment of all that Washington has to offer. His sense of fun and his generosity know no bounds. At age 97, his memory is still sharp and his advice is always useful. Thank you, Harold. (1979 photograph by Chester Gray.)

IMAGES
of America

THE PALISADES
of WASHINGTON, D.C.

Alice Fales Stewart

*To Caroline!
Best wishes!
Alice Fales Stewart*

Published by Arcadia Publishing
Charleston SC, Chicago IL, Portsmouth NH, San Francisco CA

Printed in Great Britain

Library of Congress Catalog Card Number: 2005922730

For all general information contact Arcadia Publishing at:
Telephone 843-853-2070
Fax 843-853-0044
E-mail sales@arcadiapublishing.com
For customer service and orders:
Toll-Free 1-888-313-2665

Visit us on the internet at http://www.arcadiapublishing.com

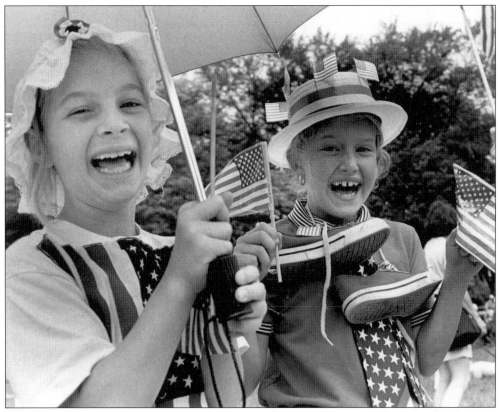

JULY FOURTH REVELERS HILARY DuPONT AND CAITLIN WATSON. The Palisades Citizens
Association revived the tradition of the Fourth of July parade in 1966 after a two-year hiatus.
The tradition is now firmly in place. Every year, thousands of people line MacArthur Boulevard.
Many spectators and participants wear patriotic colors or costumes such as these girls wore in
the 1990s. (NWC.)

CONTENTS

MAP OF THE PALISADES. This map was drawn by cartographer R. W. Galvin for the 1966 Golden Anniversary Celebration of the Palisades Citizens Association (PCA), at which time Harold Gray's 1956 history of the neighborhood was updated with the help of Ruth Aull and published as a pamphlet together with the program for the celebration.

ACKNOWLEDGMENTS

Thanks go to the Palisades Citizens Association (PCA) for its encouragement and help with this undertaking and to the Palisades Community Fund for its generous financial support. In particular, Lynn Scholz and Polly Johnson were unstinting in satisfying every technical requirement of this project. They know how thoroughly I relied on their help, skill, and good judgment. Janet and Darryl Garrett, Elizabeth and Tom Fox, Pablo Saelzer, David Mitchell, Sid Banerjee, and Kate Koffman all responded with characteristic warmth and willingness to my sporadic requests for assistance. I am indebted to them for their support, advice, and kindness.

I would like to thank Nancy Hammond, chairman of the Palisades Community Fund, for her suggestion that I send out a letter to all members of the PCA asking for photos for the book. That letter opened a floodgate of images from photo albums, attics, collections in bureau drawers, and suitcases under beds. The list of credits on page eight shows how many people entrusted me with their cherished pictures. They told me stories, gave me clippings, opened the family bibles, took photographs and paintings off the walls, offered me dinner, and gave me the names of others to contact and to interview. If this book succeeds in capturing any of the charm of this place, it is because of the outpouring of information and the pictures I received. Unfortunately I was not able to include everything, but I am grateful to everyone who responded so generously.

This book owes much to the librarians who seemed as eager as I was to resolve my research questions. Heading the list are Margaret Goodbody, Peggy Appleman, Karen Blackman-Mills, and Faye Haskins at the Washingtoniana Division of the Martin Luther King Jr. Memorial Library. Gail Rogers McCormick and Ryan Shepard at the Kiplinger Library of the Historical Society of Washington were extraordinarily resourceful and helpful. The staff at the Maryland State Archives, the National Archives, and the Library of Congress helped me find things I didn't even know existed.

I am grateful for the valuable history research and by the collegial kindness offered by Priscilla McNeil, Carlton Fletcher, Dan Dalrymple, Nancy Kassner, Stepher R. Potter, David Murphy, Andrea Schoenfeld, Brian Kraft, Cici Hughes, Patrick Shaughness, and Judith Lanius. I am likewise indebted to the staff members at Chrome, Asman Custom Photo Services, the Palisades Image Center, Penn Camera, and especially to Jim Johnson at Picture Story Studio. Without their patience and competence, this book would never have become a reality.

To Anne Ourand, Penny McGinn, Stu Ross, Mark Hall, Alan Aiches, Alma Gates, Harold Gray, Dan Dalrymple, and others in the PCA who have had special roles in the production of this book, you have my deepest thanks. To Kathryn Korfonta, my editor at Arcadia, I thank you for all you did to keep me on track and for your many roles in making our book come to fruition.

Despite all this help, I remain responsible and regretful for any errors which may appear, and would be grateful to have them pointed out to me.

Picture Credits and Copyright Information

Most of the images used in this book were generously offered by Palisades residents. The initials at the end of each caption indicate the source of each picture, and a key to the initials is listed below. Chris Kain at the *Northwest Current* opened his photographic archives to me. Tom Jacobus and Billy Wright of the Washington Aqueduct located several specific images. I was given permission by Dean Randy Ott to reproduce some pictures taken in connection with a 1985 class at Catholic University's School of Architecture. The Colonial Dames of America, Chapter III gave access to their records and lent many materials. The National Geographic Society allowed me to reproduce several pictures from their image collection. Other images came from the Washingtoniana Division of the Martin Luther King Jr. Memorial Library, from the Library of Congress, and from the Historical Society of Washington.

AD—Alan Darby
AO—Anne Ourand
APC—Anonymous Private Collection
AS—Alice Stewart
BA—Barbara Allan
BBM—Beatrice Berle Meyerson
CDA—Colonial Dames of America, Chapter III
CG—Connie Gelb
CUA—Catholic University of America
DB—Duard Barnes
DD—Dolly Dockins
DHD—Dana and Helen Dalrymple
DPD—Doug Dupin
DTM—Dick and Terri Myers
DWD—Dan Dalrymple
EL—Elaine Lozier
FP—Fred Pelzman
GT—Gene Tweraser
HDJ—H. D. Johnson
HG—Harold Gray
HSW—Historical Society of Washington's Kiplinger Library
IC—Ivy Caldito
JC—Julia Cancio
JJP—Jim Johnson, Picture Story Studio
JK—John Kennedy
JN—Jerry Nestingen
JR—Julie Russell

JW—Jo Waters
JRW—Jim Whittaker
LC—Library of Congress
LL—Leslie Livingston
LRG—Mrs. Louise Redmon Geesling
LS—Linda Starke
MB—Mark Binsted
MHM—Michael and Hannah Mazer
MLK-W—Martin Luther King Jr. Memorial Library, Washingtoniana Division
MT—Matt Thorpe
NBL—Nellie Barnes Livingston
NGS—National Geographic Society
NPS—National Park Service
NWC—*Northwest Current*
PCC—Palisades Community Church
PM—Priscilla McNeil
PMJ—Polly and Mike Johnson
PP—Penny Pagano
PPL—Palisades Public Library, Lucy Thrasher
RB—Rose Marien Black
RE—Richard England
SDS—Skip and Deb Singleton
SPS—St. Patrick's School
VCL—Virginia Clark Levy
WA—Washington Aqueduct
WES—Wallace Shipp
WS—Wuanetta Stottlemyer

INTRODUCTION

There is a certain geographic and historical inevitability that settlement should have occurred here on the shores of the Potomac River, for there are abundant natural resources, and the river is navigable up to this point. Furthermore, when Washington, D.C., was chosen as the site for the federal capital, this area was included within its boundaries. As the nation grew, so did its capital and our neighborhood.

The river was used for transporting goods and people during prehistoric and colonial times. Since then, several man-made transportation corridors were constructed parallel to the river. These continue to be the most prominent features of our landscape today. They include the Chesapeake and Ohio Canal, the spur of the Baltimore and Ohio Railroad, the trolley tracks, and MacArthur Boulevard (formerly "Conduit Road"), which is traveled by a stream of commuters going to and from work each day.

Our terrain is rough and hilly, as the name "Palisades" would indicate. The natural contours of the land are beautiful in themselves, and they provide spectacular views overlooking the river from the bluffs that form the palisades. In terms of the built environment, it is highly varied. We still have some fairly large private landholdings, and we have blocks of apartment buildings along sections of our main corridor. We have young families and an assisted living facility for our older folks. We have some grand embassy residences and some group homes for needy people. We have a few town and row house developments and some private houses designed by world-class architects.

The purpose of this book is to trace how this area developed from prehistoric times to the present, and to illustrate that development visually. The transportation routes that mark the surface of our neighborhood still influence the outlook of our residents. This is a very active and outward-looking community, and it always has been. We are located at the extreme western corner of Washington, D.C., with Georgetown to the southeast, Montgomery County, Maryland, to our northwest, and Virginia across the river. We share public transportation, utilities, traffic, and environmental issues with those other neighborhoods and jurisdictions, and yet our focus is primarily on Washington, whose civic and population center is about five miles east, or down-river.

Despite the constant flow of people through our neighborhood and despite the attention given to what is beyond our borders, we remain essentially a cohesive and well-defined, albeit a diverse, community. We are defined by our natural boundaries—the river and the high ridges (Loughboro and Foxhall Roads), which are the watersheds the Potomac River's tributaries—and by our commitment to economic diversity and to a sense of community. Soaring land values attest to the desirability of living in the Palisades, and many developers, both from within and outside our area, are engaged in a building boom. The same sort of transformation occurred in the early 20th century, when farms were transformed by land speculators and subdivided into building lots. The tall and elegant houses built at that time are now our historic treasures.

One hundred years ago, the pace and pressure of development probably met the same resistance it does today. Yet the Palisades seems able to maintain a stable population, and its residents still enjoy a very friendly, small-town atmosphere.

2424 CHAIN BRIDGE ROAD. This photograph of one of the old Sherier farmhouses was probably taken in the 1950s. The Sheriers were important landowners in this area in the 19th century. Sherier Place, which used to be spelled Sherrier, is named for them. (HG.)

One

THE POTOMAC RIVER AND THE EARLY INHABITANTS

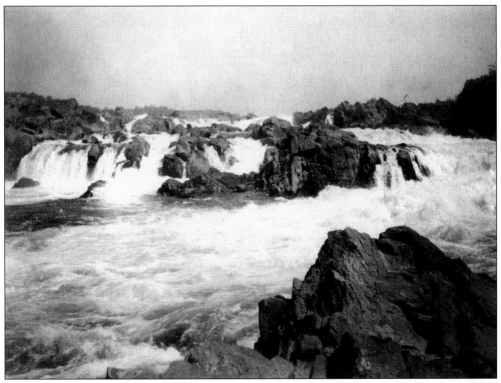

GREAT FALLS OF THE POTOMAC RIVER, 1891. People have always been captivated by the wildness and drama of this natural feature. Long before photography, Virginian Henry Fleet wrote in the 1630s that he could "hear the falls to roar about six miles distant." In 1937, John L. Weaver recalled the annual "summer picnic trip" to Great Falls with his father, who was born in 1828. (MLK-W, Neg. #5965.)

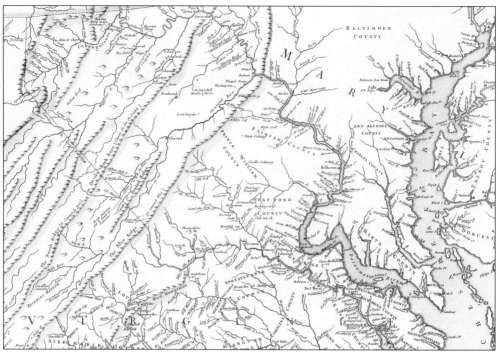

Map of Potomac River, 1751. This is a section of a map of Virginia and Maryland drawn by Joshua Frye and Peter Jefferson, Thomas Jefferson's father. George Washington would have been about 19 when this map was drawn. Washington, D.C., would be located in what was then vaguely designated as Charles County. The map also shows the whole length of the Potomac River, from its source high in the Blue Ridge Mountains to its mouth at the Chesapeake Bay. (Poster reproduction of the map owned by the author.)

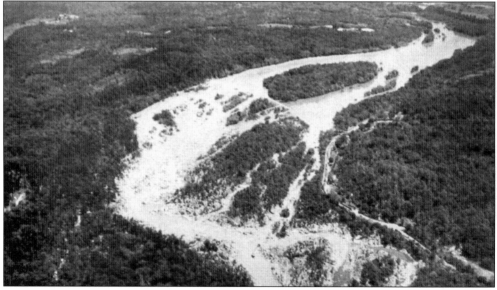

Aerial View of Great Falls of the Potomac River. This picture gives a good idea of the extent of the falls and of the size of the islands and boulders that make up Great Falls. (MLK-W, Neg. #12432, photograph by Army Air Corps.)

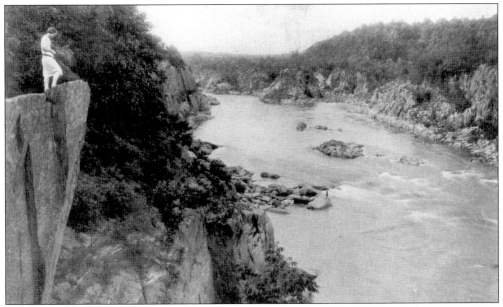

THE POTOMAC GORGE CUTS THROUGH WALLS OF ROCK. The water level at Great Falls depends on the amount of rainfall upstream and varies on any given day. In this photograph, the river is relatively low, exposing walls of gneiss and granite that were useful to the Native Americans in making tools. The exposed rocks, when the water was low, and the greater turbulence when it was high, impeded navigation through the falls. (MLK-W, Neg. #12411, NGS, photograph by Clifton Adams.)

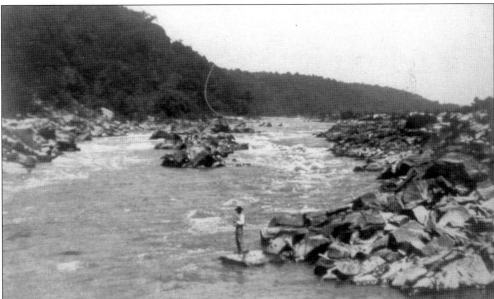

FISHING AT LITTLE FALLS. This scene has been repeated for generations and in all seasons. The Potomac Flats on the right make this the narrowest part of the river below Great Falls, and thus they are and have been a prime fishing spot for centuries. Sturgeon abounded here in the 17th century; fishermen nowadays mostly catch white perch, shad, herring, striped bass (rockfish), and catfish, depending on the season. (MLK-W, Neg. # 6012.)

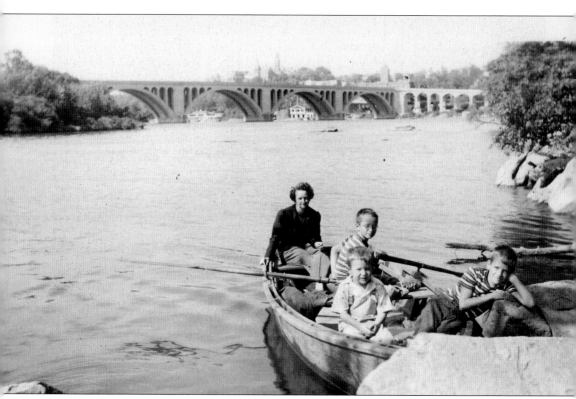

ROWING BELOW KEY BRIDGE NEAR GEORGETOWN, SUMMER OF 1949. Lida Ruth Gray, Harold Gray's wife, with their three sons, Chester, Gordon, and Tom, are seen here rowing on the more tranquil waters of the lower Potomac with Key Bridge shown in the background. The Grays moved to the Palisades because of the neighborhood's proximity to the river. This area, below Little Falls and Key Bridge, is the tidewater area. (HG.)

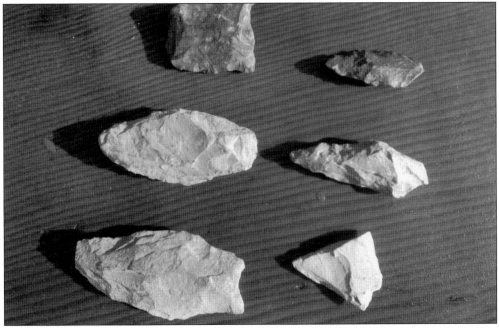

RHYOLITE POINTS FOUND RECENTLY NEAR SHERIER AND NEWARK. Astonishingly even after a century of archaeology in the Palisades, amateur "diggers" today can still unearth evidence of prehistoric Native Americans. These spear-points were probably made from stone quarried about 40 miles upriver near Point of Rocks. Other artifacts (not shown) reveal a later stage of development—the Archaic or Woodland stage—which is characterized by some settlements, pottery, and agriculture. (DPD.)

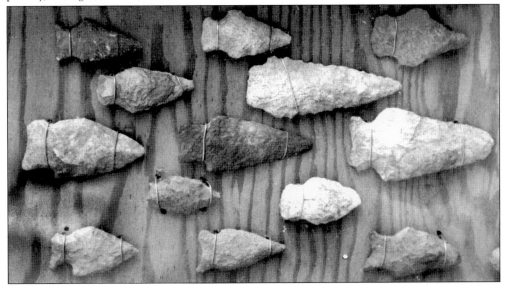

ARROWHEADS. These projectile points, found at various sites in the Palisades, were used for hunting. Local natives were also skilled fishermen. Henry Fleet, who spent five years in captivity living with them, wrote in the 1630s that "The Indians in one night commonly will catch 30 sturgeon. . . where the river is not above 12 fathom broad; and as for deer, buffaloes, bears, turkeys, the woods do swarm with them." (AD.)

15

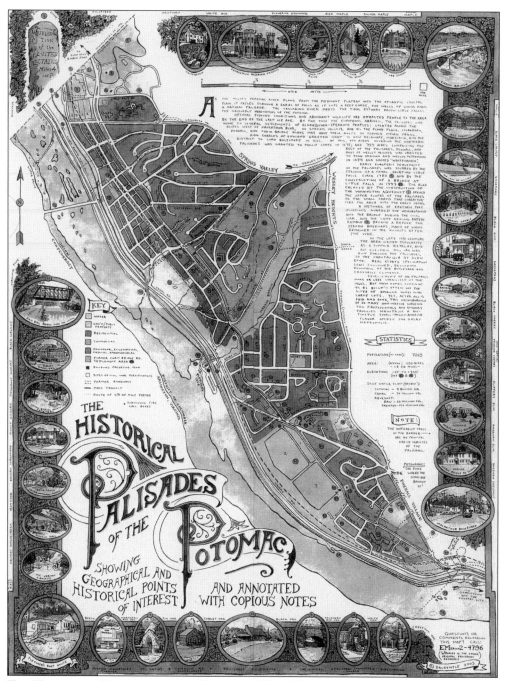

The Historical Palisades of the Potomac. This 2003 map by artist Dan Dalrymple was inspired by an earlier advertisement for a real-estate development (shown on page 66). The numbers identify "geographical and historical points of interest" and are keyed to extensive explanatory notes on the back. Dan grew up in the Palisades and documented many places of interest and events as they occurred. (DWD; LC #G3852.P2E635/2003.D3.)

Two

COLONIAL AND EARLY
FEDERAL PERIOD

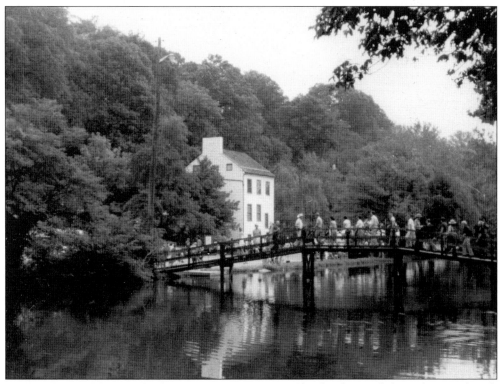

ABNER CLOUD HOUSE, OLDEST IN THE PALISADES. This land passed through many hands between the late 17th century and when Abner Cloud acquired it in the 1790s. This stone building was his house. It was completed in 1801 and predates the Chesapeake and Ohio (C&O) Canal, seen here, by nearly 30 years. Abner Cloud operated a flour mill next to his house. The mill was used until 1880. After Abner died in 1812, his widow, Suzanne, stayed in the house until 1852, after which it again passed through many owners. The canal is maintained by the National Park Service as part of the C&O Canal and National Historic Park. (AD.)

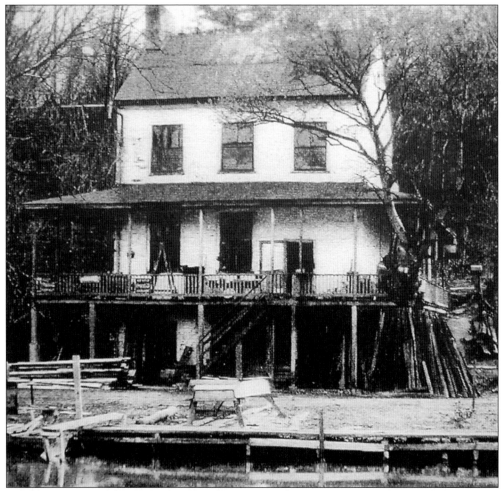

ABNER CLOUD HOUSE IN 1938 BEFORE RESTORATION. As its various owners have come and gone, the Cloud House has undergone several transformations. It looks today much as it did when it was completed by Abner Cloud in 1801. This picture shows how the house looked in 1938. The porches were removed in 1962, after the Park Service had taken over the building in 1957. The building remained empty until the Colonial Dames of America, Chapter III, who had been looking for an historic house in the District of Columbia to restore as their contribution to the nation's bicentennial celebration, were directed to the house. Members of the Colonial Dames are all descended from colonists. Now some 30 years later, Chapter III maintains the interior of the house and has preserved much of the history of the Cloud family and other early colonists. (CDA.)

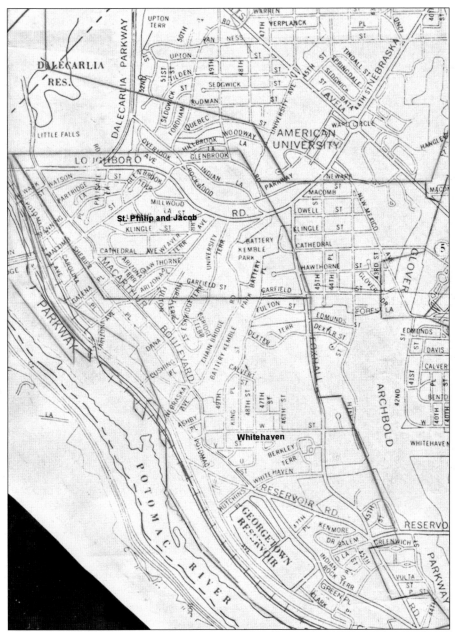

ST. PHILIP AND JACOB (1674) AND WHITEHAVEN (1689). King Charles I gave to Maryland's Colonial or "Proprietary" governor Cecil Calvert, the first Lord Baltimore, the authority to grant landholdings to colonial settlers for having transported men from England to live in the colony or for other service. The two earliest land grants in this area covered just about all of what is today the Palisades. The first was the St. Philip and Jacob grant of 400 acres to Phillip Lines. The second was Whitehaven, in which 759 acres were given to Col. John Addison and William Hutchison. The lines on this map showing the outlines of the lands granted are approximations, for it is often impossible to determine the exact boundaries as described on the original documents. In the 18th century, there were additional but much smaller grants named Arell's Folly (1771), Below Amsterdam (1784), Resurvey of Amsterdam (1789), and Alliance (1791). (PM.)

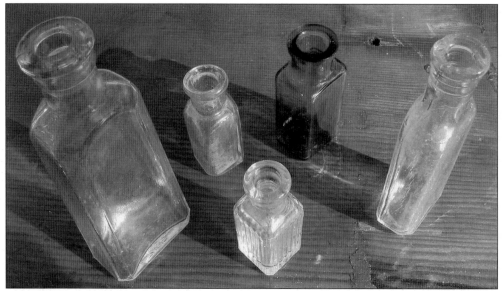

GLASS BOTTLES UNEARTHED IN PALISADES. Glass manufacturing was the first industry in the first British colony in North America. The indigenously made glass by the colonists evolved, from its beginnings in Jamestown, Virginia, in the early 17th century, into quite varied and elegant designs. These bottles and others have been unearthed in many sites within the Palisades. They probably date from the 19th century. (DPD.)

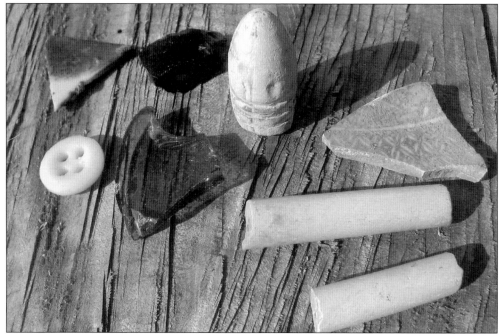

PALISADES ARTIFACTS MAY DATE FROM COLONIAL TO CIVIL WAR PERIODS. The bullet and clay pipe stems in this assemblage of artifacts give an indication of their age. These objects, as well as the button and the glass and pottery fragments, were found at the same site in the Palisades. With soil disturbance having occurred for centuries, one will often find objects from different eras buried at approximately the same depth. (DPD.)

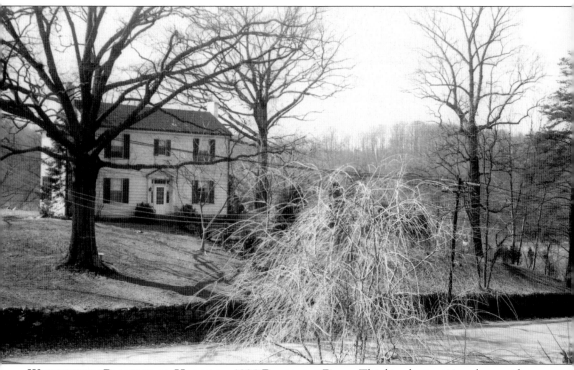

WHITEHAVEN PLANTATION HOUSE AT 4928 RESERVOIR ROAD. This handsome privately owned house is as distinguished as the Cloud House, although it less well-known. It overlooks the Cloud House and has a magnificent view of the river. It retains its original character despite numerous additions and remodeling. It is listed as the Thomas Main House on the D.C. Inventory of Historic Places. Documentation for this site and information on Thomas Main are quite scarce, but most sources agree that Thomas Jefferson would come here to buy plants from Thomas Main, a horticulturalist, to take to Monticello. In 1811, Jefferson wrote "if heaven had given me choice of my position and calling, it should have been on a rich spot of earth, well watered. . . . No occupation is so delightful to me as the cultivation of the earth, and no culture comparable to that of the garden." The current owners of Whitehaven are reintroducing plant cuttings from Monticello. (HG.)

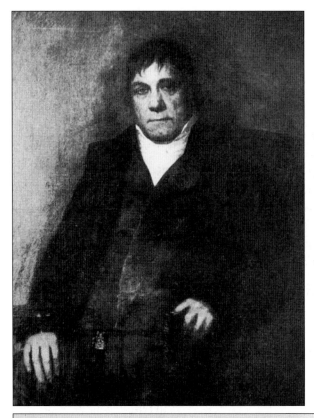

HENRY FOXALL AND HIS "COLUMBIAN FOUNDRY." Henry Foxall emigrated from England to Philadelphia in 1797, where he became acquainted with some of the leaders of the new United States and where he manufactured iron cannons for the government. In 1799, a $20,000 government contract to produce more iron cannons lured him to Washington. His first house was on Thirty-fourth Street in Georgetown just a few blocks east of the foundry, which was located just about at the point where MacArthur Boulevard now joins with Canal Road. The tributary (subsequently called Foundry Branch) supplied water power to the foundry, which was conveniently situated both to receive the necessary raw materials from Western Maryland and to deliver the finished product to the government. This foundry produced cannons used in the War of 1812. (Photos by JJP.)

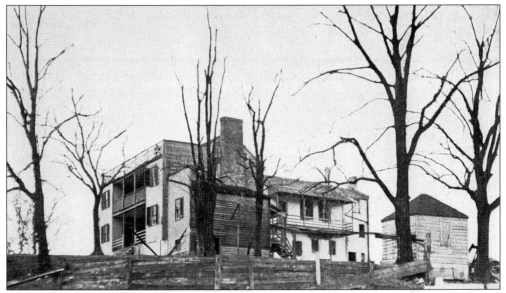

SPRING HILL, FOXALL'S COUNTRY HOUSE. By 1823, when Foxall wrote his will, he had built this country house that his family enjoyed as their summer residence, establishing a precedent for the "summer resort stage" in the Palisades. Spring Hill was located just east of what is now Foxhall Road, a little below Reservoir Road where P Street is now. Once called Ridge Road, it was renamed for Henry Foxall and an H was added.

FOXHALL ROAD AREA ATTRACTED FAMOUS PEOPLE. It is believed that Foxall's "firm friend," Thomas Jefferson, came to visit him at Spring Hill and that they played violin duets together on the upper gallery. In the 20th century, Foxhall Road was home to Nelson Rockefeller, Duncan and Marjorie Phillips, Carmen and David Lloyd Kreeger, Morris and Gwendolyn Carfritz, and Perle Mesta. In the interim, slaughterhouses and two Civil War batteries were located there. (LC #USA7-25907.)

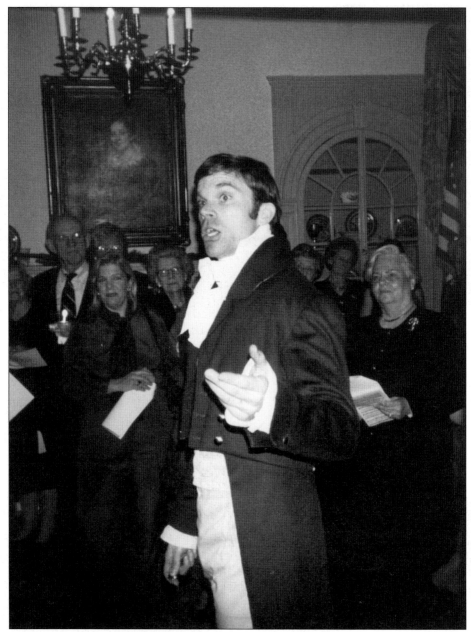

DRAMA AND MUSIC BRING OUR HERITAGE TO LIFE. As a way of fostering an appreciation of our early heritage, Chapter III of the Colonial Dames of America will sometimes bring performers to the Cloud House for special occasions. In 1996, for example, actor Allen Gephart, shown here and playing the part of Francis Scott Key, dropped in for a surprise visit to the delight of the company. He recalled his role in the War of 1812, and then sang our National Anthem, the words of which he had written nearly a century and a half earlier. Francis Scott Key, 1779–1843, was born in what was then Frederick County, Maryland. He was district attorney for the District of Columbia. On another occasion, a young singer in historic dress sang "The Battle Hymn of the Republic," written by Julia Ward Howe, whose direct descendant is a member of Chapter III of the Colonial Dames of America. (CDA.)

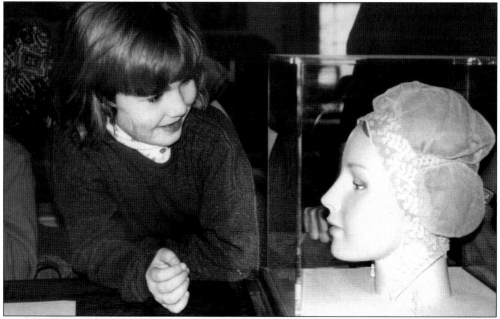

EMZA'S 1820 WEDDING BONNET. During a specially arranged "History Mystery Tour" in 1996, young Miranda Wheeler was photographed looking at Emza Cloud's wedding bonnet. Abner and Suzanne Cloud's daughters, Artemesia and Emza Cloud, married brothers of Thomas Carbery Jr., who became mayor of Washington, D.C., in 1822. First Artemesia married Lewis Carbery in 1817, when she was 17. Later Emza married James Carbery. (CDA.)

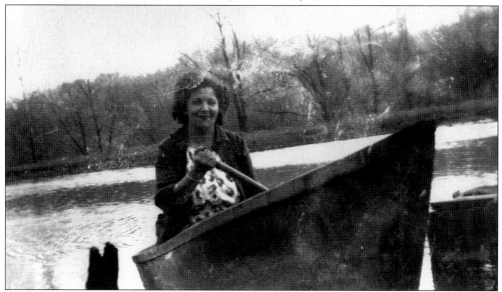

HELEN ATOHI REDMON IN A FAMILY-MADE BOAT, MID-1940S. Helen Redmon and her husband, Albert M. Redmon, owned the Cloud house until the federal government took it over by eminent domain in the mid-1950s. Until then, Mrs. Redmon owned nine cottages on the canal, which she rented out year-round to families in the post-Depression era. She also rented canoes, rowboats, and parking spaces to fishermen and boaters. Her daughter and granddaughter still live in the area. (LRG.)

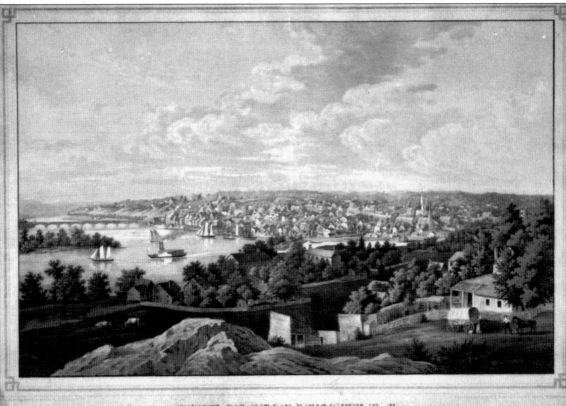

VIEW OF GEORGETOWN D. C.

THE VIEW OF GEORGETOWN LOOKING UPRIVER. This famous painting purports to show Georgetown and its surroundings in 1830. What this "snapshot" does not show, however, is that the transition from woodland to farmland and eventually to town was a gradual and difficult one. Writing a report on plantations to London in 1678, Lord Baltimore said that outside of "St. Maries" where the provincial assembly and court met, the buildings in the rest of the province are "very meane and little. . . . We have none that are called or can be called towns. . . . [I]n most places there are not fifty houses in the space of thirty miles." While Georgetown was laid out in the mid-18th century, the area to the west of it was only very sparsely inhabited and still quite heavily wooded a century later. In the next chapter, we will try to gain some insight into how our area—on the western outskirts and on the heights beyond Georgetown—evolved in the decades after the federal capital moved here in 1800. (LC #3B52969U.)

Three

AGRICULTURE AND TRANSPORTATION ROUTES DEVELOPED

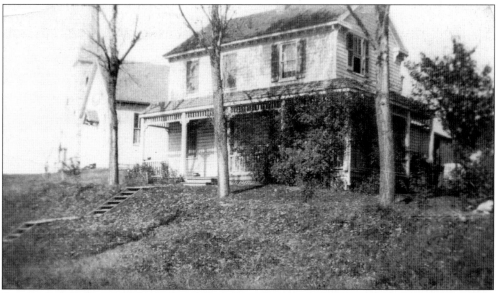

SHUGRUE FARMHOUSE. The Shugrues were dairy farmers in the neighborhood and, like other commercial farmers, required transportation to deliver their dairy products to market. The 1880 City Directory lists Michael Shugrue's occupation as "milk" and his address simply as Conduit Road (later changed to MacArthur Boulevard). The Shugrue family used to keep their cows on Nineteenth Street in town until it was prohibited. They then brought them to graze in this neighborhood, where they had a summer place with much land. Our Lady of Victory Church, seen here in the background, is on land which once belonged to the Shugrues. The Shugrue house stood on what is now the foot of Whitehaven Parkway. The Shugrues were typical farmers in that they moved out here from the city; and the markets where they sold their products were not primarily in this neighborhood. (HSW, CHS # 08152.)

WHO WAS C. CHERRY? The goal of this 1861 Boshke map was to document every building and road in Washington. It lists a "C. Cherry," whose name does not appear on any other source. Might he be the same person as "C. Shorga" (from the grand duchy of Hesse-Darmstadt) on the 1860 census, and also the patriarch "Conrad Sherier" in Harold Gray's history? Spelling in the 19th century was capricious, especially among immigrants. (PM, AS.)

MIKE SHERIER'S FARMHOUSE AT 2428 CHAIN BRIDGE ROAD. Sherier Place was named for this family, who owned land here before the Civil War. Mike was one of Conrad's sons. The original house, which was a simple rectangle with a gable roof, first stood above MacArthur Boulevard. The porch and rear section were added later. (AS.)

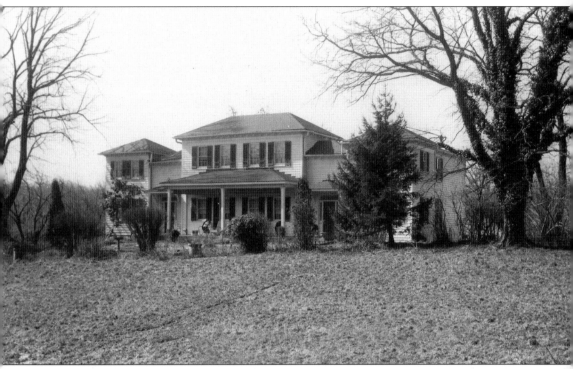

BOYLE HOUSE AT 4452 MACARTHUR. This house stood on the site of Riverside Hospital, previously occupied by the Psychiatric Institute of Washington. Thomas J. Boyle, the owner, sold meats first at Riggs Market and eventually also at Western Market, according to city directories of the second and third decades of the 20th century. We can imagine that the house was added onto incrementally, as was (and is) so often the case when families prosper and grow. (HG.)

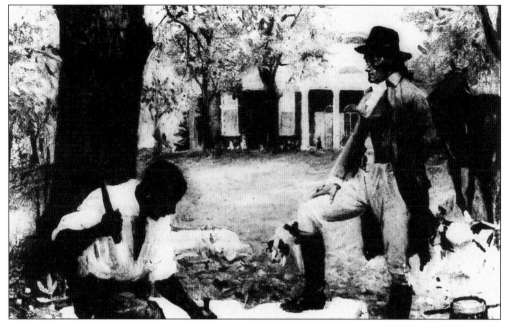

PAINTING OF THOMAS JEFFERSON SUPERVISING THE WORK OF A SLAVE. Agriculture in much of the tidewater area of Virginia and Maryland was suitable for slave labor. Even on our hilly terrain, many farmers were slave owners. Federal Census Slave Schedules listed slave owners by name but the slaves only by age, sex, and other characteristics. There is some evidence that some slaves here were manumitted before emancipation. (LC #3A52162U.)

A GEORGETOWN MARKET ON THIS SITE SINCE THE 1790S. Georgetown's more urban residents no doubt enjoyed our farmers' produce, and some of our farmers may have relied on their slaves to get their milk, meat, and grains to market. The Boyles, the Clouds, the Foxalls, the Shugrues and the Sheriers are not known to have had slaves. However, the Carberys, who married with the Clouds, the Pierces, the Weaavers, and many other families, did. (See page 52) (NWC.)

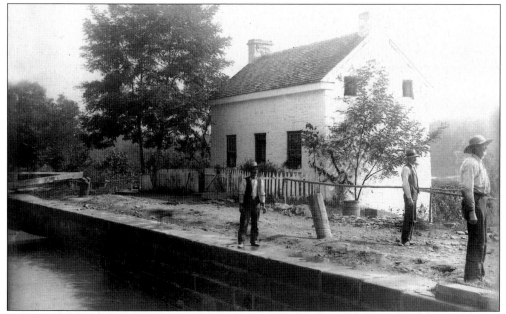

LOCKMEN ANTICIPATE ARRIVAL OF BARGE ON C&O CANAL. The 185-mile-long C&O Canal was designed to link the two great river systems on either side of the Appalachian Mountains and thus to facilitate the economic integration of the country. Locally it served to bring in raw materials and to carry farm products and raw or finished goods to Georgetown markets. It was used for commerce from the late 1820s until 1924. (LC #BH 8233-24.)

ELLA BARNES RIDGEWAY'S HOUSE ON CANAL ROAD. The wide clapboards on the exterior of this house indicate that the lumber was made from old-growth trees and imply a relatively early construction date. Old maps show many houses on Canal Road, a prime location for people involved with the canal trade. A 1954 source tells of the removal of "shanties" there. By that time, fine houses such as this one had probably fallen into disrepair. (NBL.)

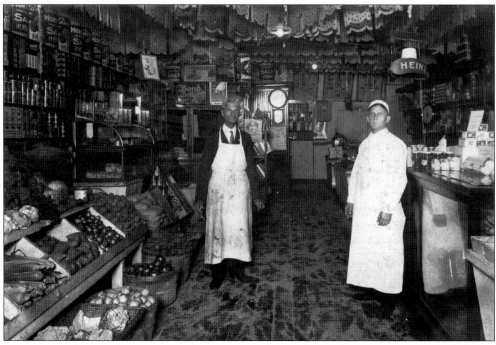

INTERIOR OF BARNES'S STORE IN GEORGETOWN (ABOVE) AND BARNES'S DELIVERY WAGON (BELOW). Enoch Barnes was a butcher at Fox's Market before opening his own store at 3057 M Street. There he sold fresh produce, packaged dry goods, meats, and a variety of other items. Much of the fresh produce probably came from his and from other farms in the Palisades such as the Sheriers'. Enoch Barnes's daughter recalls that Enoch helped Mark Sherier carry stones up from the Potomac River to build his (Mark's) house. The meat may have come from livestock farms in Virginia. Cattle were driven over Chain Bridge, taken to a pen next to the Distributing Reservoir, and then to one of the many slaughterhouses along Canal and Foxhall Roads. Nineteenth century maps show a Drovers Rest Tavern near the intersection of MacArthur and Reservoir Roads. (NBL.)

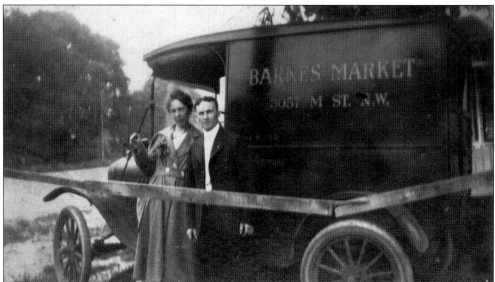

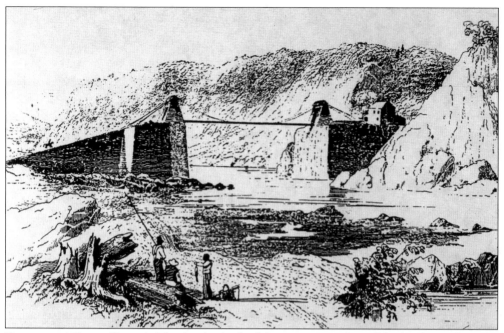

PICTURE OF CHAIN BRIDGE. The first bridge built here was a wooden toll bridge dating from the 1790s, which replaced a ferry. George Washington objected to the toll. Although there have been many replacement bridges, only the one shown here, built in 1810, was designed as a chain suspension bridge. Nevertheless, all subsequent bridges have been called Chain Bridge. (CUA.)

CHAIN BRIDGE DURING THE CIVIL WAR. While Chain Bridge was built to facilitate the river crossing, during the Civil War it became a point of vulnerability for the Union (see pages 43 and 44). During the 1850 construction of this bridge, a worker, "Bull" Frizzell, nearly died. He fell into the river and emerged with a smashed skull, his brains were said to be oozing out. Later he was convicted of conspiracy in the Lincoln assassination. (AD.)

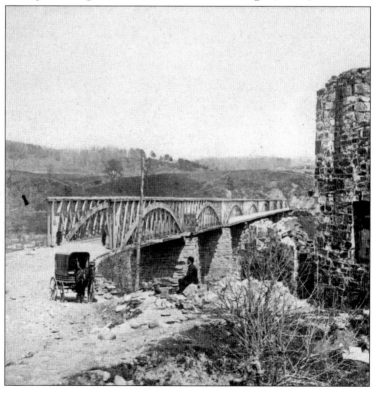

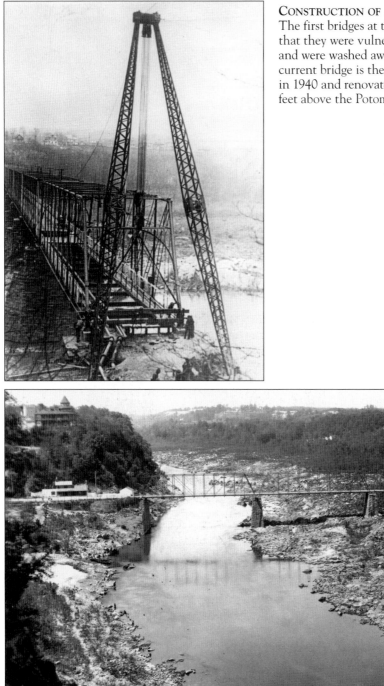

CONSTRUCTION OF A LATER BRIDGE. The first bridges at this site were so low that they were vulnerable to flooding and were washed away several times. The current bridge is the eighth. Completed in 1940 and renovated *c.* 1980, it is 45 feet above the Potomac. (AD.)

THE SEVENTH CHAIN BRIDGE (1874–1939). Notice the contrasting shorelines of Virginia, with the much steeper grade on the left, and of Washington, with the wide flats on the embankment on the right. On a "normal" flow day, the water in the river only touches the first two of the supporting piers on the left in this picture. But during heavy spring runoff, the entire flats are occasionally under water. (AD.)

Four

WASHINGTON AQUEDUCT IMPACTS AREA

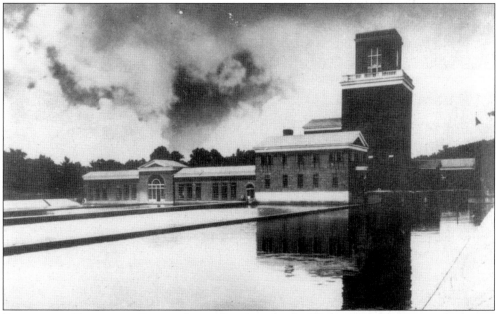

DALECARLIA FILTRATION PLANT. Groundbreaking for the Washington Aqueduct took place in 1853. The aqueduct system was designed by Gen. Montgomery C. Meigs for two reasons: to bring water for drinking and to fight fires into the city of Washington. By the 1850s, the population of Washington had exceeded the capacity of the natural springs and water wells to supply it adequately. Although this portion of the site was not developed until the 1920s, in 1858 Meigs had, with characteristic foresight, purchased nearly 300 acres of the Dalecarlia farm here. The Receiving Reservoir initially provided adequate sedimentation, but in the 1920s, a new filtration system was devised to enhance water quality. This building dates from 1928. After World War II, the further increase in population in the metropolitan area required another expansion of the aqueduct. (See page 84 and 85.) (MLK-W #153400.)

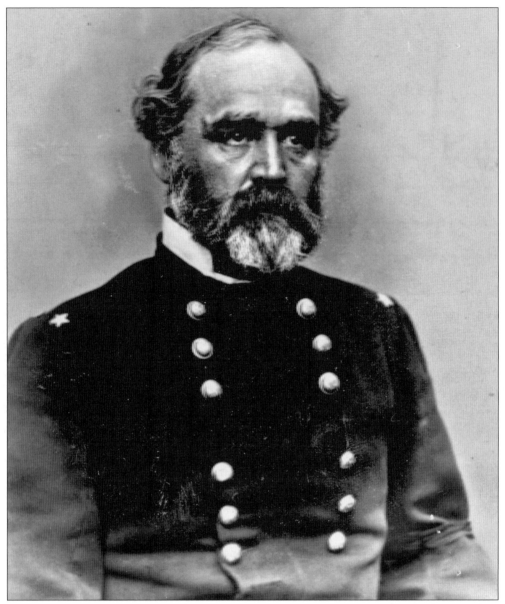

GEN. MONTGOMERY C. MEIGS. The son of a doctor, Meigs was interested all his life in public health issues, but he did not follow his father's career path. He went to West Point, graduated near the top of his class in 1836, and spent most of his life in the Army Corps of Engineers. Meigs is perhaps best known for his meticulous work as quartermaster general of the Union army, a post to which he was appointed by President Lincoln in July 1861. Washingtonians also know him as the architect of what is now the National Building Museum—formerly the Pension Office at Judiciary Square—and for his work on the Capitol. Perhaps his most enduring accomplishment was the design of the Washington Aqueduct system, to which he applied remarkable foresight and precision, and which he named "the Washington Aqueduct" to honor George Washington. Today the system he designed delivers water not only to Washington, but has been expanded to serve Arlington and Fairfax Counties in Virginia and Andrews Air Force base in Maryland. (LC #3A06167U.)

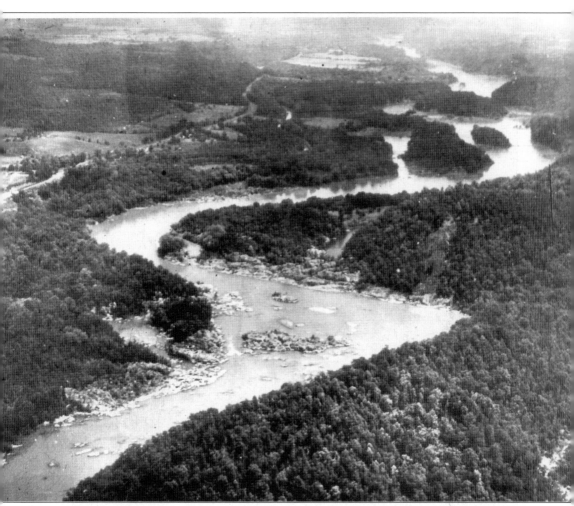

AERIAL VIEW OF POTOMAC RIVER AT GREAT FALLS, LOOKING TOWARD WASHINGTON.
Washington's water today still comes in part from above Great Falls, where the intake for the
aqueduct system has been located for more than 150 years. On the far left can be seen the extreme
western end of what was called Conduit Road (now MacArthur Boulevard), the roadbed that
was laid on top of the conduits for the city's water. (MLK-W, Neg. #5893.)

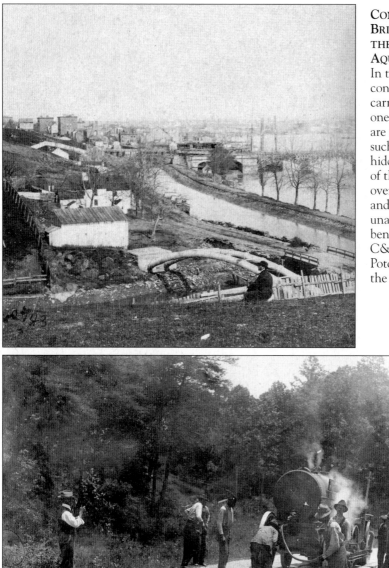

CONSTRUCTION OF A BRIDGE AS PART OF THE WASHINGTON AQUEDUCT SYSTEM. In this photograph, the conduits, or pipes, that carry the water over one of several bridges are still exposed. Many such conduits are today hidden by the surface of the roads and bridges over which we drive, and many people are unaware of what is beneath them. The C&O Canal and the Potomac River are on the right. (AD.)

APPLICATION OF "TARVIA" TO CONDUIT ROAD IN 1913. The construction and maintenance of the pipes and the superstructures required thousands of laborers over the years. In addition to three caretaker's houses (see next page), six residences for key aqueduct employees were built at the Dalecarlia plant in 1927. The aqueduct established a precedent of providing housing (facilities with "boardinghouse conditions") for its workers as early as the 1850s. (WA.)

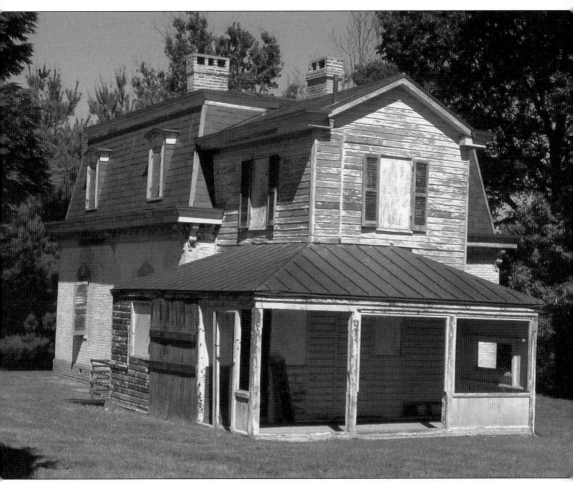

MODERN PHOTOGRAPH OF 1875 CARETAKER'S RESIDENCE AT RECEIVING RESERVOIR. Although abandoned and deteriorating, this building still stands on the hill above MacArthur Boulevard at Little Falls Road. It was one of three built at that time using the same plans. It exemplifies Meigs's goal to use standardized plans at army installations to control costs. The other two residences have not survived. (AS.)

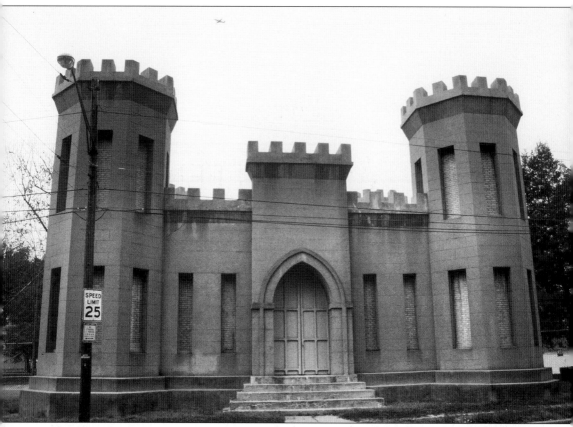

THE GEORGETOWN CASTLE GATEHOUSE. This 1901 structure sits on top of sluice gates whose function is to direct water from the Distributing Reservoir or from the main conduit into the City Tunnel, which leads to the MacMillan Reservoir near Howard University. It was designed to represent the insignia of the Army Corps of Engineers from all four sides. (AS.)

Five

CIVIL WAR DEFENSES, EMANCIPATION, AND FREEDMEN

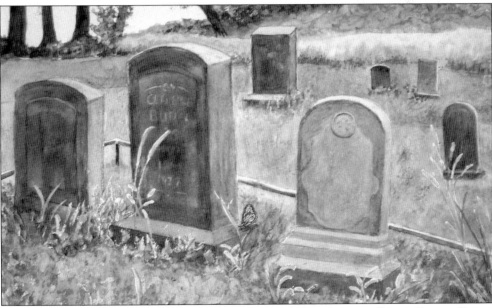

THE AFRICAN-AMERICAN "UNION BURYING SOCIETY" CEMETERY ON CHAIN BRIDGE ROAD.
During and after the Civil War, a small settlement of former slaves was established on Chain
Bridge Road opposite Battery Kemble. Many of them became landowners. Some were from this
area, some seem to have come from Georgetown. Others may have come from the surrounding
slave states of Maryland and Virginia, because emancipation came to Washington in April 1862,
three years before the passage of the 13th Amendment. This cemetery represents part of the
evidence of that settlement. This watercolor by local artist Jim Whittaker was made especially for
the 2004 Neighbors Through ART event in commemoration of the 50th anniversary of *Brown
v. Board of Education*. While the origins of this cemetery are obscure, it may date from as early as
1861, based on an informal inventory of gravestones undertaken by the author in 2000. (JRW.)

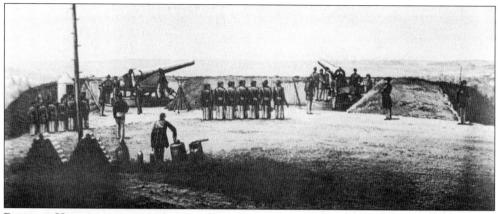

BATTERY KEMBLE DURING THE CIVIL WAR (ABOVE) AND BATTERY KEMBLE PARK (BELOW). Battery Kemble was one of six defensive structures built in the Palisades during the Civil War. With Virginia just across the river, and at the narrowest point of the river at that, our area was vulnerable. In addition to Battery Kemble and those on the next page, there were Battery Vermont, where Sibley Hospital is now, and Batteries Cameron and Parrot at about the 1900 and 2300 blocks of Foxhall Road respectively. Few, if any, traces of those three remain. Today Battery Kemble is a public park. Shown in the 1960s photograph below are Gene Cohen Tweraser and her son, both of whom grew up here, playing ball together in the park. Gene's mother, Gloria Cohen, still lives in the neighborhood. At one time, there was a small private zoo owned by Victor J. Evans in the park. (CUA and GT)

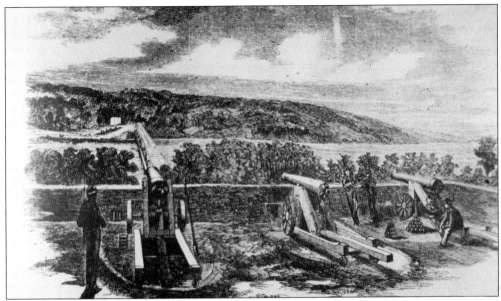

BATTERY MARTIN SCOTT. The earthworks from this battery can still be traced in the 5600 block of Potomac Avenue. There was no military action anywhere in the Palisades during the war, since Union forces occupied the land across the river. Staying alert must have been difficult, for William Scott, a young Vermont sentry, fell asleep on the job here and was about to be hanged when he received a last-minute pardon from President Lincoln. (CUA.)

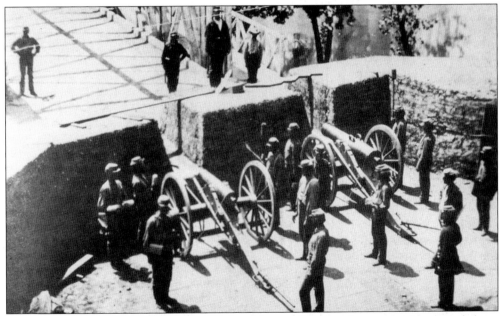

LOWER BATTERY AT CHAIN BRIDGE. While soldiers at the upper battery would primarily have relied on artillery to attack Confederate troops, were the rebels to have crossed the bridge or the river at this point, the soldiers at the lower battery would have to be prepared to engage in hand-to-hand combat. Those assigned to duty here were issued rifles in addition to two 12-pounders. This battery was evidently never given a name. (CUA.)

CAMP BLAIR INSCRIPTION. In addition to the named and unnamed batteries, there were many tent camps erected near batteries. This photograph has written on it in faded ink, "View of 'Chain Bridge' Camp Blair Georgetown D.C. / Third Regiment Michigan Infantry / July 11th, 1861 / Col. D. McConnell." Camp Blair may have been informally named for Austin Blair, the then-new governor of Michigan. (LC #B8184-10198.)

VIEW OF TENTED CAMP IN THE PALISADES LOOKING ACROSS THE RIVER FROM VIRGINIA. While this photograph is untitled and undated, it appears to have been taken during the Civil War. Might it be that the tents shown here constitute Camp Blair, and that the soldier who took the picture above lived here during the early part of the war? Notice how much of the area is still woodland or farmland. (HSW, CHS#06009.)

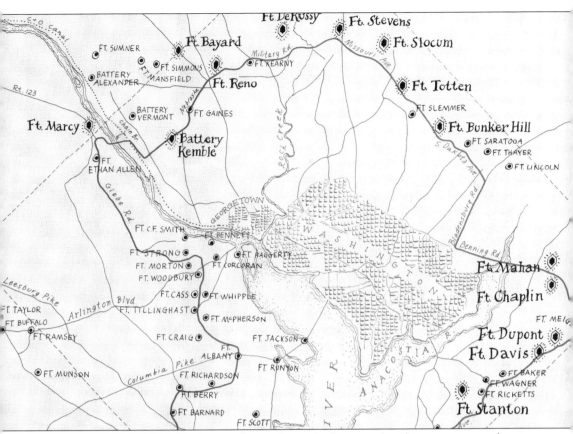

FORT CIRCLE DRIVE. There has been a plan in the works for many decades to create a roadway around Washington connecting many of the former Civil War forts. The plan was abandoned for a long while, but in 2005, there is renewed interest in it. Most of the forts on this circle are now parks located strategically on the highest points of land around the city. During the Civil War, the soldiers constructing them would have cleared land around them for visibility. They used the lumber from the felled trees to build stockade fences. These are long gone, but the open spaces remain. Many are, like Battery Kemble Park, both interesting historic sites and centers of community activity and recreation. Nebraska Avenue below MacArthur is wider than Chain Bridge Road above it because it was to be part of this circle, which is sometimes referred to as "Fort Circle Drive." On one map, the upper part of Chain Bridge Road was designated "Fort Kemble Drive," presumably in anticipation of the completion of the circle. (NPS.)

CONTRASTING SIZE OF LANDHOLDINGS BEFORE AND AFTER CIVIL WAR. The general impression of the 1857 Boschke map (above) is one of a few large farms in the clearings between the wooded areas and of a few houses built alongside the major roads. The contrasting impression of the Hopkins Atlas (below), which was made about 30 years later, is that of many small landholdings concentrated in one section. The small landholdings are in some cases probably those of the former slaves who were clustered around Battery Kemble for protection. In some cases, they are probably also the former slaves of the landowners whose names are on the Boschke map above. (LC #G3850CWD 678500, MLK-W, photograph by JJP.)

Six

RESIDENTS TURN TO BUSINESS AND COMMERCE

SNOWY LANDSCAPE BEHIND BRAZILIAN NAVAL COMMISSION WAS ENOCH BARNES'S FARM. As people moved here from downtown, Georgetown, and elsewhere, farms naturally became smaller and the landscape became more crowded. Without large landholdings, some farmers turned to other kinds of work or developed specialized sidelines. Harold Gray's 1956 history of the neighborhood refers to lettuce patches, truck farmers, florists, dairy farmers, slaughterhouses, and taverns. This landscape of assorted outbuildings suggests various entrepreneurial occupations. The Barnes family has resided in this area for at least four generations. Enoch's sister lived in the house on the canal shown on page 31. In the early 20th century, Enoch Barnes and his wife, May, lived at 5134 Conduit Road, where the Brazilian Naval Commission is located today and where this picture was taken. In addition to running this farm, or perhaps after the management of the farm passed to the next generation, Enoch worked as a butcher in Fox's Market. Eventually he opened his own store in Georgetown (see page 32). (NBL.)

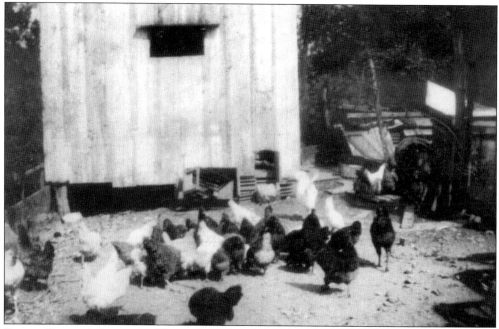

ENOCH BARNES' CHICKENS. This early-20th-century photograph shows that Enoch Barnes has built a board-and-batten chicken coop for his sizeable roost. Perhaps these chickens ended up in the meat department at Fox's Market where he worked or in his own store in Georgetown. Although building permitting began in the 1870s, people "out here" probably initially put up their own hen houses without going through the permitting process. (NBL.)

EMORY AND ETHEL SNYDER'S GREENHOUSE. During World War II, when there was food rationing, some enterprising residents built greenhouses and hothouses to supply their own and others' desire for fresh produce. Mr. Snyder's do-it-yourself greenhouse was on the trolley line, and people would get off the trolley after work and buy dinner on the way home. Even before that, though, there were building permit applications for pigeon and chicken coops and storage buildings for feed. (AD.)

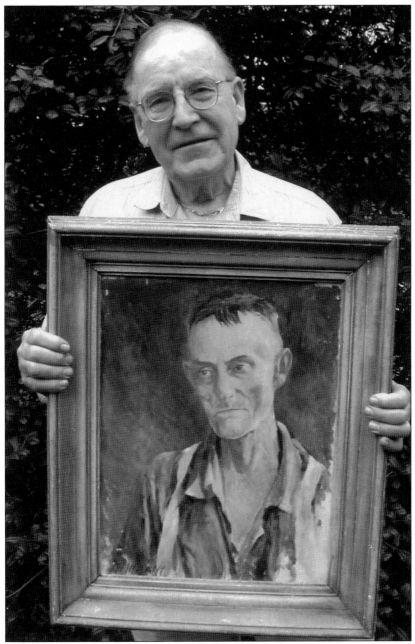

JOE FLETCHER WITH A PORTRAIT OF HIS GRANDFATHER, JOSEPH CLEVELAND FLETCHER. Joe Fletcher's grandfather was a fisherman. The business known as Fletcher's Boathouse began as a place to sell bait and other fishing gear and to service fishermen's boats. The recreational part of the business came later. The Fletchers have been in this area since the 1850s, and four generations of them have run the boathouse. Joe and his brother Ray have recently retired, but the National Park Service will keep the name Fletcher's. Joe recalled that many years ago, his grandmother would make pies and dinner for the rail men who came through on the B&O line bringing coal into Georgetown. Although there wasn't a scheduled stop at Fletcher's, they would stop the train and give the Fletchers enough coal to last until the next time they came through. (AS.)

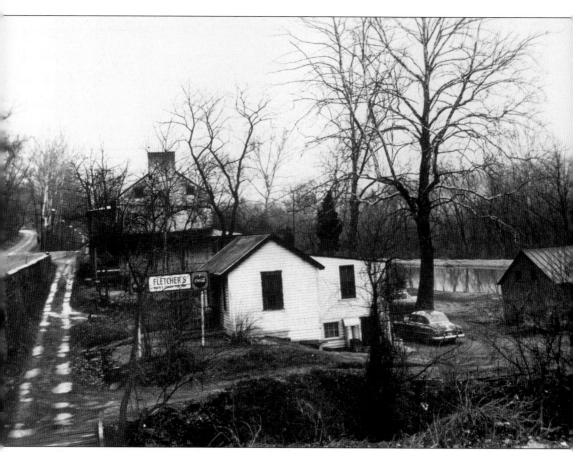

COMPLEX OF BUILDINGS AT FLETCHER'S. Fletcher's Boathouse was among the oldest family-owned businesses in the city and has undergone many changes since its beginnings. This picture shows several no-longer-extant buildings. Long ago there were paving stones on the ramp going down to the landing. (CUA.)

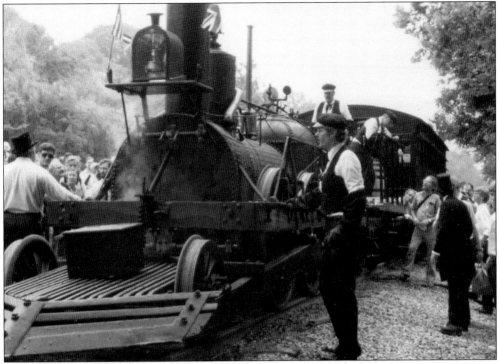

B&O Railroad Spur Built through Palisades in 1910 (above) Became the Capital Crescent Trail in 1990 (below). Although Palisades residents were not directly involved in the railroad operation, it certainly had an impact on the neighborhood. Built at the same time as the C&O Canal, it siphoned away many of the goods that the canal was supposed to carry, making the B&O a far greater commercial success than the canal. Until about 1985, the single-track spur of the B&O Railroad went through the neighborhood carrying coal from West Virginia into Georgetown, past Fletchers. In 1990, its conversion into the Capital Crescent Trail was made possible by the national "Rails to Trails" legislation. (AD, AS.)

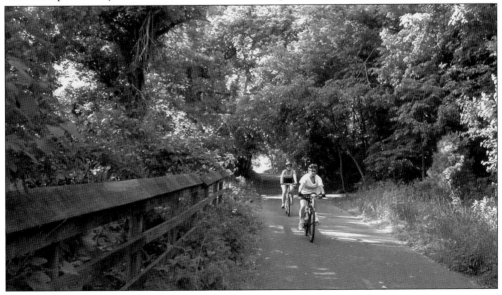

FOUR GENERATIONS OF WEAVERS PHOTOGRAPHED AT W. T. WEAVER AND SONS IN GEORGETOWN.
The Weavers were among the biggest landowners in the area. The center portrait is of W. T. (Walter
Thomas) Weaver who, with his brother Francis, opened the W. T. Weaver and Sons hardware
store in 1889. Two other brothers went into real estate. The portrait on the left is of W. T.'s son
James Bryce Weaver Sr. On the right is W. T.'s grandson, James "Jim" Bryce Weaver Jr. Jim's sons,
Michael and Bryce, are shown below the portraits. Much of the early family history was written
by W. T.'s mother, Augusta, about her husband and W. T.'s father, Charles (1828–1883), and his
brother Joseph. Augusta's memoirs record that Joseph purchased a slave family one day on the
spur of the moment in order to keep them together. In 1862, government records show that Joseph
Weaver received compensation for the emancipation of the Cephus family. Augusta, writing in
1897, credits her brother-in-law for helping the Cephus family buy a few acres of land near them.
The Cephus (Sephas) name is among the landowners on an 1887 map (see page 46). (AS.)

THE FOX FAMILY AND WALLACE SHIPP IN 1944.
The Fox family owned the grocery store and gasoline station on MacArthur Boulevard at Cathedral Avenue. They were leaders in the business community and in the Palisades Community Church. Shown here are Alan Wayne Fox, holding a cat, Ezra Fox, Virginia K. Fox, and Wallace Shipp, who was on home leave after three years in the Pacific aboard the USS *Callaway*. (WES.)

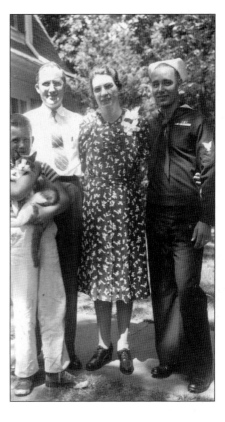

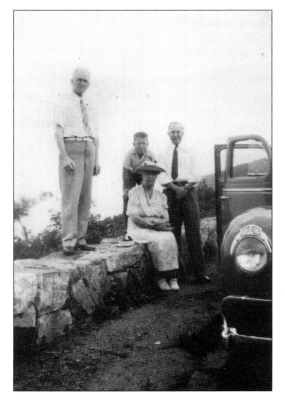

WEEKEND OUTING TO SKYLINE DRIVE.
This photograph, probably taken in the mid-1940s, shows Enoch and May Barnes with Alan Wayne Fox and Ezra A. Fox and the vintage touring car that enabled these friends to undertake such trips. Enoch Barnes worked as a butcher in Fox's Market. (NBL.)

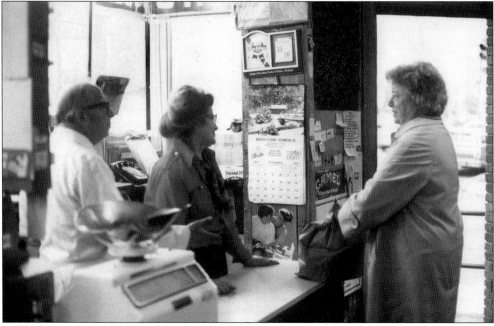

BARRY AND REGINA MAUSKOPF AND CUSTOMER. The District Grocery Store, where Listrani's stands today, was for years a social center of the neighborhood. Run and owned by Barry and Regina Mauskopf, it was a place where families were extended credit without asking and where children were always welcomed and given a candy. Barry delivered groceries in his off-white station wagon after hours to those who did not drive. (AD.)

BARRY MAUSKOPF AT THE DISTRICT GROCERY STORE MEAT COUNTER. A former neighbor wrote in a posthumous tribute to Barry that he "ran the store like a community center, which it became, and he was for many of us a social worker, banker, charity, teacher and friend." So beloved was he that after he returned to work following surgery, traffic jams occurred as people slowed down to greet him outside the store. (AD.)

ANN HAND'S JEWELRY STORE. This jewelry store began in a small cottage in the Palisades in 1988. Known for their distinctive patriotic designs, Ann's pins have been worn by many first ladies and other prominent Washington women. Here Ann Hand's daughter Catherine stands next to a framed picture of Secretary of State Madeleine Albright, who is shown wearing one of Ann's pins. (AS.)

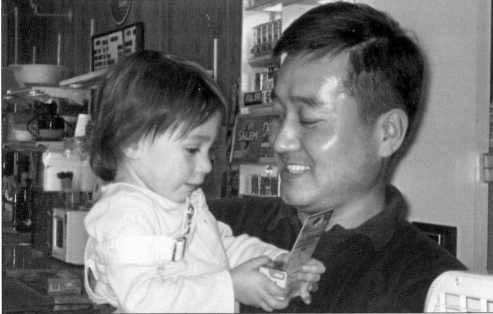

MR. LEE AND SOPHIA KENNEDY AT MIMI'S. Wooseong Lee and his wife Yunhee ("Helen") have owned Mimi's since 2001. They are the third owners of the 5435 MacArthur Boulevard convenience store, named for the daughter of the first owner. The Lees came from Korea in the 1990s. Here Mr. Lee holds little Sophia Kennedy, who calls him by the Korean word for uncle. (JK.)

MACARTHUR CARE PHARMACY'S 1997 VALENTINES DAY DECORATIONS DELIGHTS CUSTOMER JERRY NESTINGEN. This drugstore was on the boulevard for nearly 50 years, starting about 1950. Before that, it was Koenig's drugstore. Now Blacksalt, the restaurant and fishmonger, has taken over the site. (JN.)

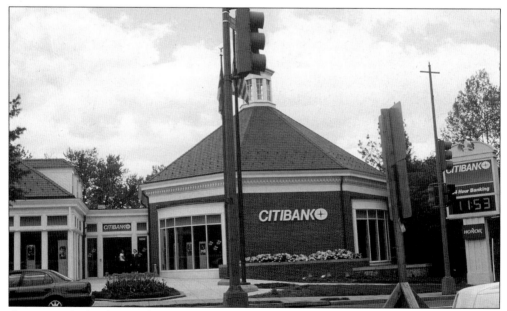

CITIBANK. Citibank started as City Bank of New York in 1812 and now has branches in over 100 countries and throughout the United States. Although a corporate giant, this small branch is a part of and contributes in various ways to the neighborhood. Its managers have been leaders in the local business community, they support the parade every year, and they have exhibited the work of many local artists (CUA.)

Seven

SUMMER RESORT STAGE AND OUTDOOR RECREATION

SUMMER CAMP IN THE PALISADES. As long as there have been cities, people have probably longed to get away from them. As Washington developed, many who had the means to acquire a "summer place" did so. Some built them with their own hands, while others hired professionals. It is difficult to know what would typify a summerhouse here, because little remains that is identified with the "summer resort stage," which occurred from around 1900 until the stock market crashed in 1929. This house began as a Boy Scout summer camp, probably in the 1920s, according to the current owner who has lived in it since 1948 and has made only minor alterations. Perhaps there were many such houses at one time. Today this house evokes the charm and simplicity of a by-gone era. Now the Palisades has become part of the city, and many of the permanent residents have summer homes elsewhere. (AS.)

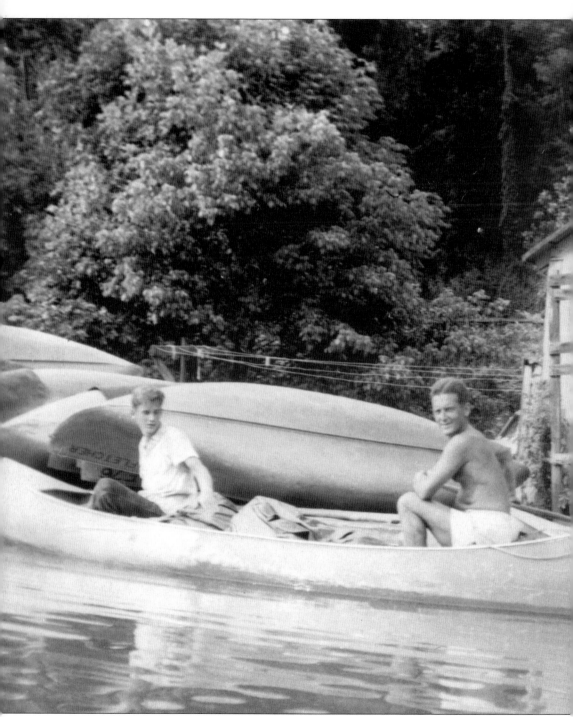

END OF THE TRIP. This is the cover photo. Taken on June 23, 1955, in front of Fletcher's Boathouse, it shows Tom Gray, Harold Gray, a crow, George Argenbright, Gary Moore and Chester Gray at the end of a 90-mile canoe trip on the Shenandoah, the Potomac, and the C&O Canal. A small section of the road-bed of the B&O Railroad is on the upper right corner of the photograph. The building, constructed during World War I, is no longer standing, but it is where the canoes

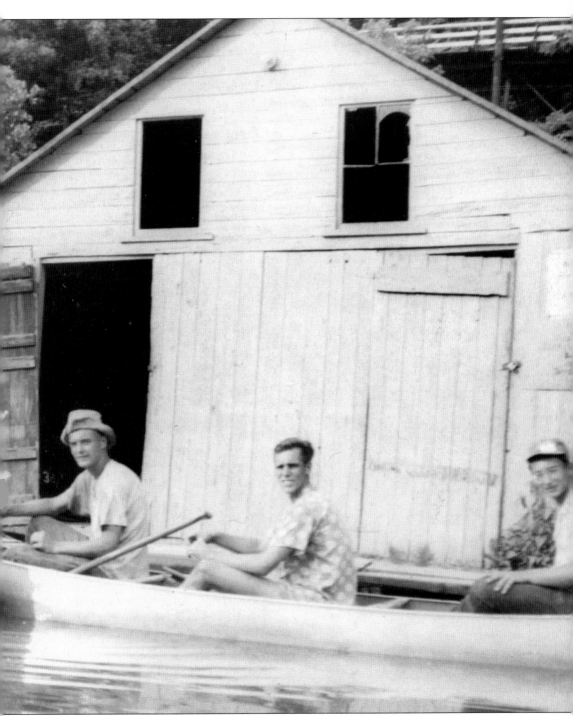

were kept for many years. Behind it is Joe and Ray Fletcher's grandfather's house (not visible); his clothes line and a corner of his "two-holer" (two-seat outhouse) can be seen just above and to the right of Harold's head. Because of the great fishing, the natural cove, and the canal, the Fletchers located their business here. Much later, Fletcher's Boathouse became the catalyst for many of the popular outdoor recreation activities that the area is known for today. (HG.)

PEDESTRIAN DUARD BARNES COMMUTES ON THE TOWPATH. One way of avoiding rush-hour traffic is to walk to work. Attorney Duard Barnes, a Palisades resident, walked about five miles to his office in the Interior Department downtown for about 20 years. While walking, he read poetry and many of the classics. He took the bus home in the evening. The towpath is also a commuting route for cyclists, but it is busiest on weekends, when it is shared by casual walkers, joggers, and bike-riders. (DB, NGS.)

PICNIC TABLES AT FLETCHER'S. This has been the site of many family reunions, graduation parties, birthday celebrations, and casual picnics. The overhead foliage provides shade in the summer, but there is a tranquil beauty to this spot at all times of the year. (JN.)

FRED PELZMAN PAINTING BICYCLE SHED AT FLETCHER'S BOATHOUSE. Fred Pelzman's paintings record many of our local scenes. Fred and his wife Frankie have lived in the Palisades for over 40 years. Fred's father grew up in southeast D.C., Fred grew up in Cleveland Park, and his children grew up here. Like the Pelzmans, many Palisades residents today have moved here from other neighborhoods. (FP.)

MEMORIAL BENCH AT FLETCHER'S COVE. This table and bench are a memorial to Maude Lewis Thorp (1960–1989) and to Lynn Wilson Thorp (1924–2001), donated by Matthew Thorp. Some of the trees at the site were also planted in Maude's memory. The painting is by Fred Pelzman. (Photograph by Nicole Mariotte, courtesy of MT.)

BILL WATERS AT ABOUT AGE THREE, C. 1920. The baby in this photograph moved to the Palisades in 1957 and became active in the community. He was elected president of the Palisades Citizens Association in 1968. Also pictured is William H. Waters Sr., who grew up and raised his family in Georgetown. This picture was taken at the Washington Canoe Club on the Potomac. (JW.)

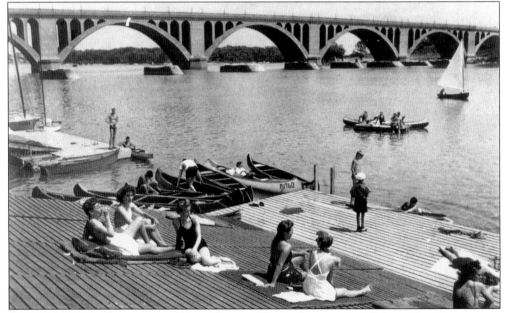

SUNBATHERS AT ONE OF THE BOAT CLUBS. The earliest rowing club on the Georgetown waterfront was established in 1859. It evolved into the Potomac Boat Club. Since then, there have been many others over the years: the Washington Canoe Club, Jack's Boathouse, the Georgetown Boathouse, and, of course, Fletcher's in the immediate neighborhood. Boat ramps made ideal sunbathing spots when that was still thought to be a healthy pastime. (MLK-W, Neg. #5918, NGS, Photograph by Robert F. Sisson.)

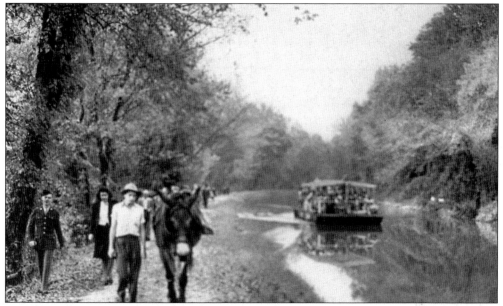

BARGE IN THE CANAL PULLED BY MULES. After goods were no longer transported on the canal, passengers went from Georgetown to Glen Echo on the *Canal Clipper*. The mules that pulled it used to graze in the fields across from Georgetown University Hospital before that area was built up. Nowadays visitors can ride only a short way up the canal from the National Park Service office in Georgetown. (CUA.)

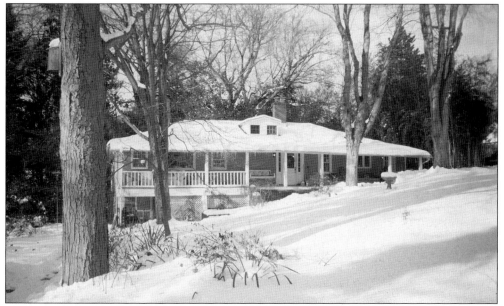

PRIVATE RESIDENCE MAY HAVE BEEN OUTDOOR DANCE HALL. In 1910, an application was filed to build a "Public Pavilion" here near Sherier and Manning Place. Since 1936, at least, this house has been a private residence. Like others in this neighborhood, the house was duplexed during World War II because of a housing shortage. When the current owners redid the floors, they found there had been partitions every eight feet, adding evidence to the oral tradition that this house was a bordello at one point. (AS.)

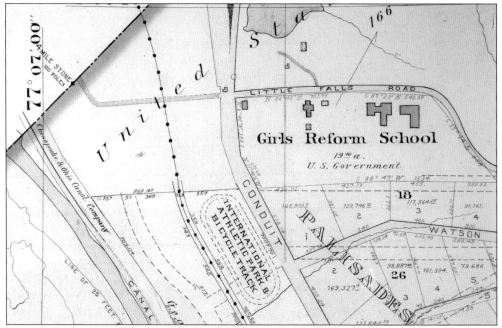

MAP SHOWING BICYCLE TRACK. Bicycles became immensely popular in America after being introduced here during the 1876 Centennial Exposition. This 1903 map shows an "international athletic park and bicycle track" with dotted lines, which might mean that it was at that time a planned facility. In the absence of additional documentation, it is not certain whether the track was actually ever built. (MLK-W, photograph by JJP.)

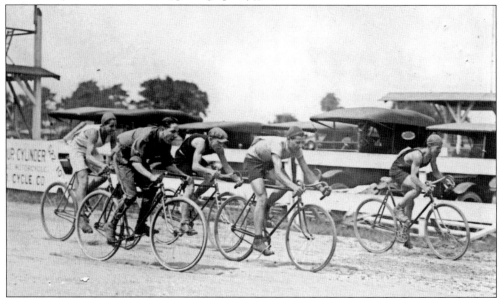

BICYCLE RACING. Bicycle clubs, each with their own uniforms, proliferated and competed against each other during the Gilded Age in Washington. In 1895, approximately 1,000 people watched about 50 contestants compete in the "Sunday run," a 20-mile course over a "rough and lumpy" Conduit Road. It went 10 miles out from the "lower reservoir" and back. The date and exact location of this photograph is unknown. (LC #3C10897U.)

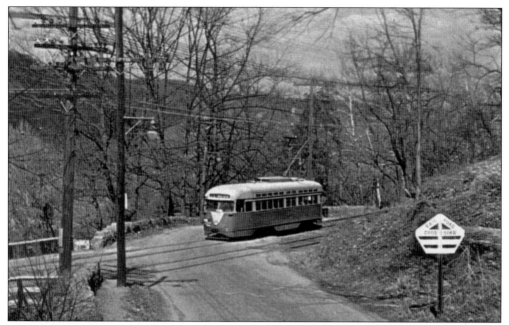

CAPITAL TRANSIT TROLLEY #20 AT RESERVOIR ROAD, 1951. Many Palisades residents today still remember taking the trolley to work downtown, missing the last trolley home after staying out on a "late date," or taking it out to Glen Echo. It ran frequently, and there were several stops in the neighborhood. Its route along Sherier Place explains the wide median strip there. (NBL.)

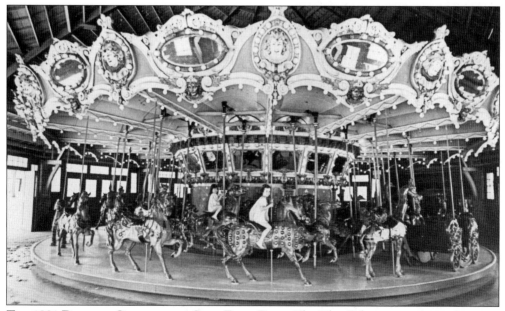

THE 1921 DENTZEL CAROUSEL AT GLEN ECHO PARK. The Glen Echo amusement park was on the site of a Chautauqua summer camp. It was associated with a late-1880s Maryland real-estate development plan not unlike the Palisades of the Potomac (see Chapter Eight). During the first half of the 20th century, the park grew, becoming an immensely popular center for family entertainment and adding new attractions every year during its heyday. (NWC.)

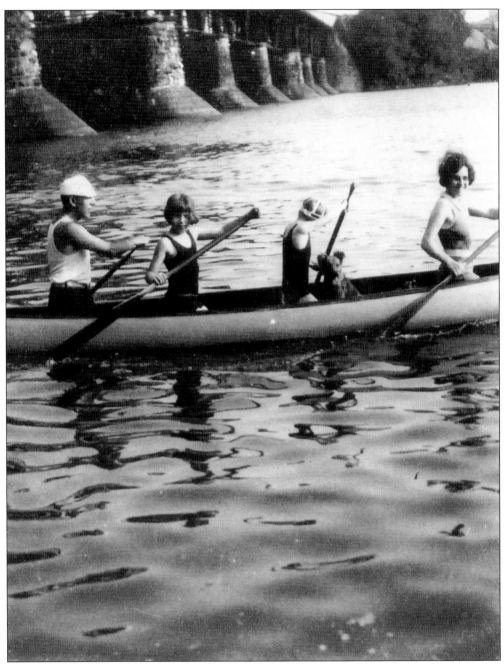

HAZZARD FAMILY CANOES PAST AQUEDUCT BRIDGE, C. 1920. Jack Hazzard, who was part Onondaga Indian, had already made his first canoe about eight years before he came to Washington in 1914. He went on to design paper canoes and sailing canoes. He won the Free-for-All at the President's Cup Regatta in 1934 and 1935. Here Jack is shown with daughter Dolly and son John, Tippy the dog, and his wife, Gertrude Hazzard. The Aqueduct Bridge, shown here, used to carry water from the C&O Canal across to Virginia. It is altogether separate from the Washington Aqueduct designed by Gen. Montgomery Meigs. The Aqueduct Bridge was replaced by Key Bridge. (DD.)

Eight

EXPECTATIONS FOR SUBDIVISIONS INITIALLY UNFULFILLED

1822 FORTY-SEVENTH STREET, NW This may have been one of the houses associated with the 1902 Senate Heights subdivision on Forty-Seventh Street and New Cut (later Reservoir) and Conduit (later MacArthur Boulevard) Roads. It was torn down shortly after this picture was taken in 2000. There were no street numbers on Forty-Seventh Street as late as 1922, according to building permits and the city directory from that year. The very first subdivision in the neighborhood, Part o Haarlem, dates from 1876. It was near the intersection of Foxhall and Conduit Roads. One source says it was named for the farm from which the subdivision was taken, another that it was named after the town in the Netherlands and was developed by some of the same investors who had developed Harlem in Manhattan. A series of speculators and developers came into this area starting before 1880. They subdivided what had been farmland with the intention of developing and selling real estate. This process was occurring throughout the city because of the population growth, and because of the nation-wide suburbanization movement. (AS.)

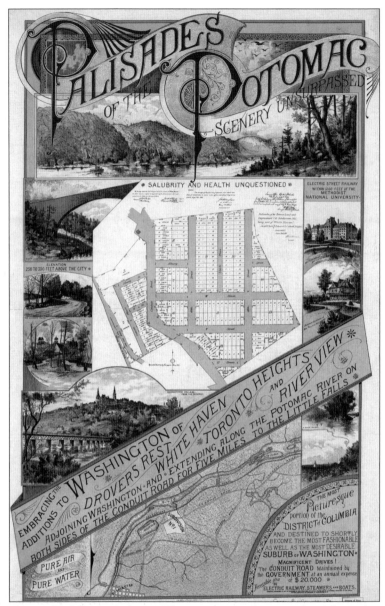

Palisades of the Potomac Poster. This promotional poster dates from the early 1890s and represents the dreams of the major development group of this area. The Palisades of the Potomac Land Improvement Company filed with the city four different plat maps representing four different purchases of tracts of land and proposed developments between 1890 and 1891. Many of the current streets were laid out and street names were assigned. Incorporated in 1890, the company's president was, for many years, Stilson Hutchins, who had founded the *Washington Post* in 1877. Other leading owners, investors, or brokers included Jacob P. Clark, Edward B. Cotterell, and John C. Hurst. The company intended to develop land on the Virginia side of the river as well, but the Virginia plans never came to fruition. In 1892, Jacob Clark recorded another subdivision plan, commonly called the "Clark and Hurst subdivision" for the area just next to and downhill from the Distributing Reservoir, including Elliott Place and Clark Place. (LC #G3852.P64G46/1890.B71.)

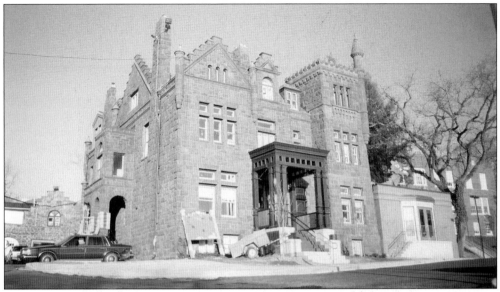

JACOB CLARK'S RESIDENCE AT 4759 RESERVOIR ROAD. Now the main administrative building of the Lab School, this house was completed just before the 1893 crash and subsequent real estate slump, which dealt a severe blow to the aspirations of the developers. Clark was a Canadian whose Gothic-Revival, red sandstone house was used as a Florence Crittenden Home for Unwed Mothers from before 1930 at least into the 1960s. (CUA.)

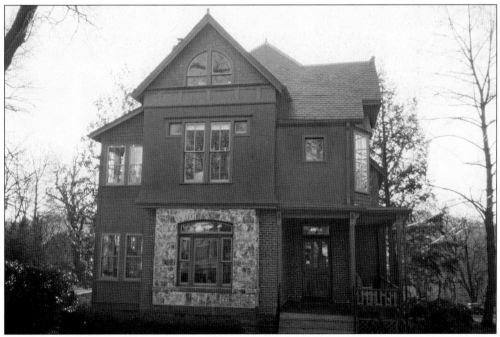

ARCHITECT RICHARD OUGH'S HOUSE ON MACARTHUR BOULEVARD. Richard Ough designed many of the residences for the principal developers of the Palisades of the Potomac and many houses also in the Maryland suburbs and other parts of the city. He designed and built this house for himself and occupied it beginning in 1893–1894 at the latest. He later moved to Friendship Heights and eventually to California. (AS.)

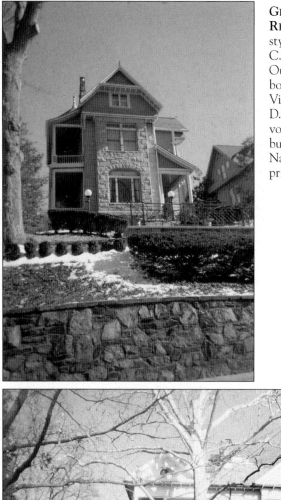

GLEN HURST AT 4933 MACARTHUR, RECENTLY LANDMARKED. This high-style Victorian house belonged to John C. Hurst. Probably designed by Richard Ough, it will be featured in a forthcoming book (to be titled *Painted Ladies*) about Victorian houses. In January 2005, the D.C. Historic Preservation Review Board voted unanimously to landmark the building and to recommend it for the National Register of Historic Places. It is privately owned. (SDS.)

FORTY-NINTH STREET RESIDENCE. The granite wall surrounding this house is characteristic of other houses designed by Richard Ough in the Palisades in the 1890s. This house is on Forty-Ninth Street above where it intersects with Ashby Street. It must have been placed there so as to take advantage of the view and the breezes. (AS.)

4925 MacArthur Boulevard. This house has many features in common with the previous four. Once a private residence, it was later used by the Washington Psychoanalytic Society. Since 2002, it has been part of St. Patrick's School. (AS.)

Row Houses on Elliott Street. The 1892 development proposed by Hurst and Clark was to have occurred here. Nothing remains from that era except that the streets today reflect the development plan. These row houses may have been the first in the Palisades. Across from them is now the Center for Urban Ecology, which stands where the Reservoir School was located from the 1920s into the 1950s. (AS.)

CONTRASTING HOUSES STYLES SHOW LATE 19TH CENTURY DIVERSITY. Probably both of the houses on this page date from the developer era; both were already quite historic when Harold wrote the neighborhood history 50 years ago. The one above, called Sunnyside, is on V Street within the area planned for the development of the first Palisades of the Potomac Tract in 1890, and it dates from around that time. The house below, from approximately the same time period, is on what was once called Weaver Street (now Arizona Avenue) on what was then still farmland. These houses reveal some of the differences in terms of occupations and income levels in the neighborhood over 100 years ago. (AS.)

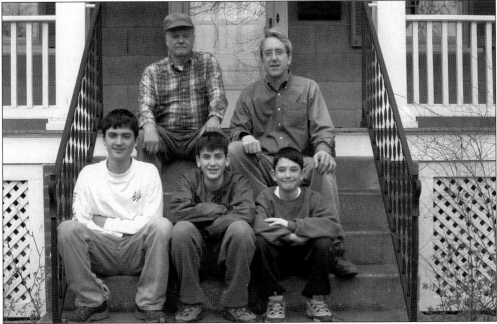

THREE GENERATIONS OF BINSTEDS AT HOME ON SHERIER PLACE. The Binsted family came from England to the United States via Canada in 1892. Carpenter Thomas immigrated here to work for the Palisades of the Potomac developers. Later Binsteds also worked as carpenters; others became proprietors of Binsted's Esso at 4812 MacArthur, an ironworker, a clerk, a lawyer, and a stenographer. Pictured here on the top step is retired electrician Thomas Binsted; just below him is architect Mark Binsted; and on the bottom step are Mark's sons Alex, Derek, and Keith. (MB.)

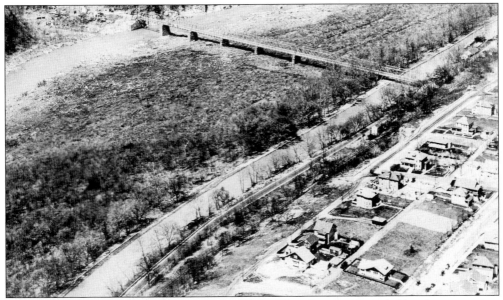

AERIAL PHOTOGRAPH SHOWS MANY EMPTY LOTS. This photograph, probably taken some time between 1910 and the late 1930s, reveals a moment in the process of development on and above Potomac Avenue between about Macomb and Galena Streets. Notice the different sizes and styles of houses and that there are still many empty lots. (WA.)

OLD HOUSES ON LOWER MACARTHUR BOULEVARD. In spite of the developers' initial disappointment, there were eventually a good many lots developed with substantial houses in the first two decades of the 20th century. These two date from around 1912, and are among the few older houses on lower MacArthur Boulevard today. Many of the others have been replaced by apartment blocks that were constructed in the post-World War II building boom. This area was part of the Serrin farm. (AS.)

DETACHED ROW HOUSES ON SHERIER PLACE. In part because of the financial downturn in 1893, the developers's dream were initially unfulfilled. Many of them left town. Most of the original subdivisions had planned lots with 50-foot wide frontage. When sales languished, these were further subdivided into 25-foot-wide lots, which explains why many of the houses on Sherier today are long and thin, almost like row houses, but separated. (AS.)

Nine

GOVERNMENT PRESENCE PRECEDES FOUNDING OF PCA

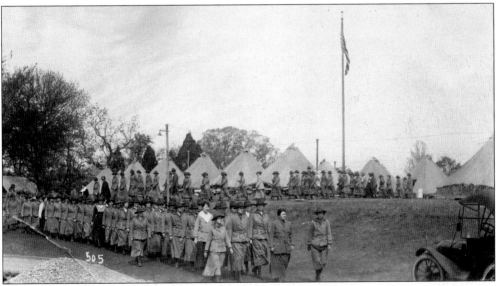

NATIONAL SERVICE SCHOOL SETS UP WORLD WAR I SUMMER TRAINING CAMPS IN PALISADES. The federal government touched what is now the Palisades neighborhood even before the new capital moved here in 1800, as you will see on the next page. The Washington Aqueduct was a federal project, and troops were stationed here during the Civil War. During World War I, young women from all over the United States were stationed for training near where Sibley Hospital is today. The federal government initiated this home-front war effort, the purpose of which was for the women to replace the men who were serving in the military. Soon after the arrival of the federal presence, municipal services were established. These included schools and regular police and fire protection. Our first neighborhood association was organized in 1916. (AD.)

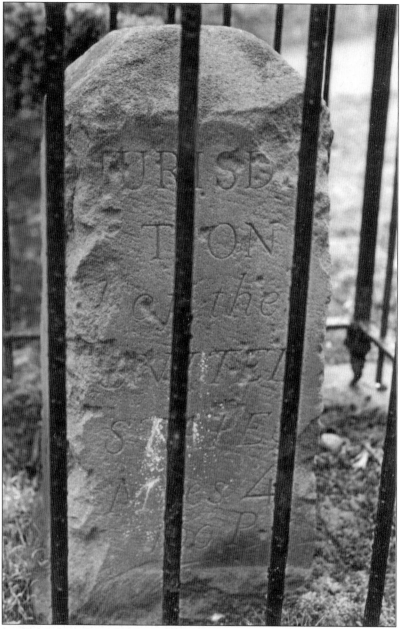

NORTHWEST BOUNDARY STONE NUMBER FOUR. The survey for the new federal city was carried out soon after the site for the federal capital was chosen. Andrew Ellicott, appointed by Secretary of State Thomas Jefferson, and his assistant, Benjamin Banneker, a free black astronomer and mathematician, surveyed the perimeter of the ten-by-ten mile square, placing a boundary stone at one-mile intervals. Their work was inspected by George Washington. The stone shown here is on the grounds of the Washington Aqueduct at the Dalecarlia Filtration Plant site. Northwest Number Five is in the woods between Sibley Hospital and Westmoreland Circle. The Daughters of the American Revolution assumed responsibility for identifying and preserving the stones in 1915, at which time the stones were surrounded by wrought iron cages. The inscription on the front of the stone says: "Jurisdiction of the United States Miles 4 200 P." (DWD.)

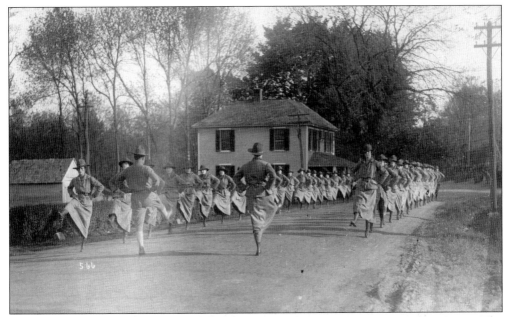

HIGH-STEPPING WOMEN MARCH IN FORMATION ALONG AN UNPAVED CONDUIT ROAD. The army, navy, marines, Agriculture Department, Red Cross, and the DAR all contributed to the recruitment and training of these young women. The trainees learned farming methods so they could increase food production. They learned how to instruct maimed and crippled veterans to weave, make pottery, and do chair caning. (AD.)

TROOPS STATIONED NEAR SAFEWAY AFTER MARTIN LUTHER KING'S 1968 ASSASSINATION. While the city was under martial law immediately following King's assassination, Palisades Citizens Association president Bill Smith drove a carload of volunteers to answer phones at the emergency information office at the District Building. PCA also donated $500 to Mayor Walter Washington to help the needy. (BBM.)

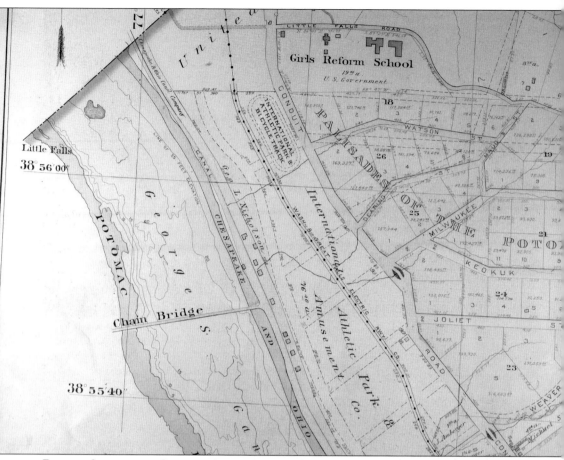

REFORM SCHOOL FOR GIRLS AT SIBLEY SITE. Built on 19 acres of an old farm to accommodate 29 girls, the school opened in 1893 with 38 inmates being admitted during the first year. Their offenses included incorrigibility and larceny. By the 1930s, there were over 100 girls ages 12 to 21 committed there each year. In 1912, it was renamed the National Training School for Girls. (MLK-W, photograph by JJP.)

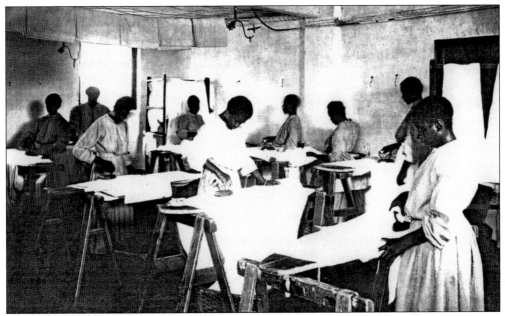

GIRLS TAUGHT TO IRON. From the beginning, the curriculum was made up of both academic learning and "industrial work," which included farming, cooking, laundry, sewing, and ironing. Girls were issued clothing when they arrived and taught how to maintain it. There was an incentive system whereby a girl could be awarded stars (plus the right to converse at meals, and to wear a white apron, for example) for good behavior and work. (AS.)

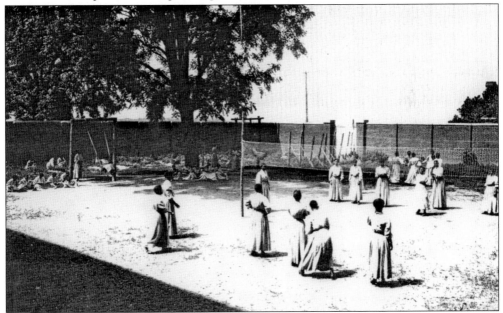

GIRLS ENJOYING OUTDOOR EXERCISE. The superintendent and her staff were very careful about the health of their young charges. Vaccinations and medical visits were routine. The girls spent much time out of doors. They eventually farmed over 10 acres that provided much of their dairy products, produce and meat. Most inmates were paroled after relatively short incarcerations, and returned to the community according to the published annual reports.

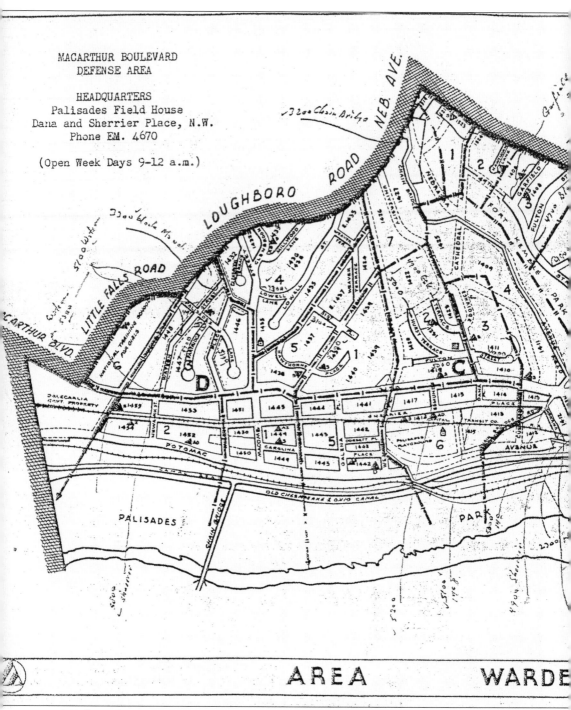

1942 CIVIL DEFENSE MAP OF THE PALISADES. During World War II, the neighborhood prepared for emergencies by establishing shelter areas in each block, by identifying three well-supplied billet posts for emergency feeding and housing, and by training air raid wardens in First Aid.

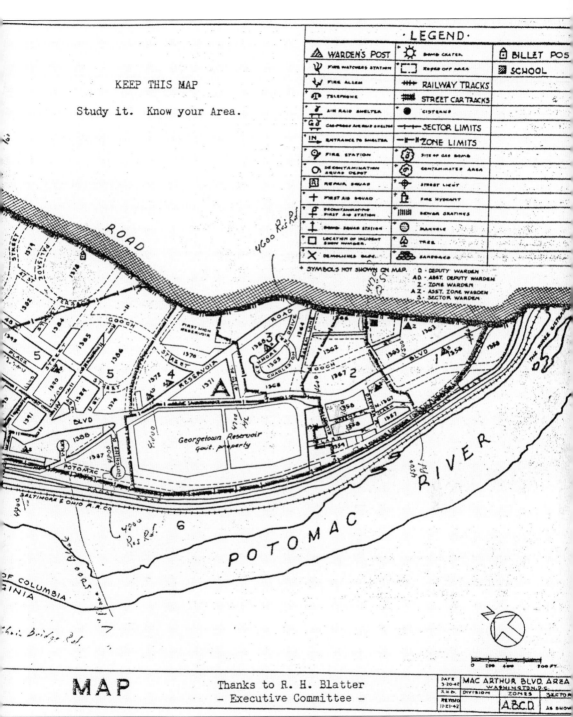

· LEGEND ·

Symbol	Description	Symbol	Description	Symbol	Description
⚠	WARDEN'S POST	☼	BOMB CRATER	🏠	BILLET POS
ψ	FIRE WATCHERS STATION	⬚	ROPED OFF AREA	▨	SCHOOL
⚡	FIRE ALARM	╈╈╈	RAILWAY TRACKS		
☎	TELEPHONE	▦▦	STREET CAR TRACKS		
	AIR RAID SHELTER	●	CISTERNS		
	GAS-PROOF AIR RAID SHELTER	—┼—	SECTOR LIMITS		
IN	ENTRANCE TO SHELTER	—╫—	ZONE LIMITS		
⊙	FIRE STATION	⑧	SITE OF GAS BOMB		
	DECONTAMINATION SQUAD DEPOT		CONTAMINATED AREA		
R	REPAIR SQUAD	⬥	STREET LIGHT		
+	FIRST AID SQUAD	H	FIRE HYDRANT		
	DECONTAMINATING FIRST AID STATION	▥	SEWER GRATINGS		
	BOMB SQUAD STATION	◎	MANHOLE		
☐	LOCATION OF INCIDENT SHOW NUMBER	⬣	TREE		
X	DEMOLISHED BLDG.		SANDBAGS		

+ SYMBOLS NOT SHOWN ON MAP.
D - DEPUTY WARDEN
AD - ASST. DEPUTY WARDEN
Z - ZONE WARDEN
AZ - ASST. ZONE WARDEN
3 - SECTOR WARDEN

KEEP THIS MAP

Study it. Know your Area.

MAP

Thanks to R. H. Blatter
— Executive Committee —

DATE 3-20-42	MAC ARTHUR BLVD. AREA WASHINGTON, D.C.	
R. N. D. DIVISION	ZONES	SECTOR
REVISED 11-21-42	A.B.C.D.	AS SHOWN

The area was divided into four zones, then further subdivided into 26 sectors, each of which had a Civilian Defense leader. (MLK-W.)

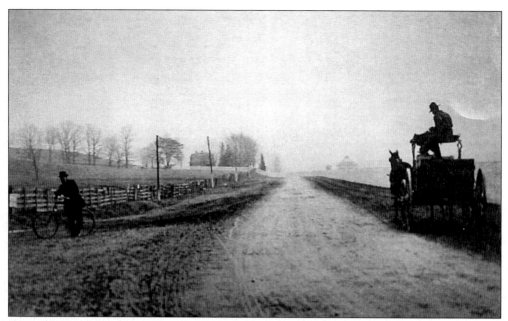

CONDUIT ROAD LOOKING EAST C. 1880. The open fields and a horse-drawn vehicle on the right support the view that agriculture remained a primary occupation "out here" until the end of the 19th century. The rounded structure in the background on the right is the Influent Gatehouse which, though inactive, still has a prominent spot at the west end of the "Georgetown Distributing Reservoir." (WA.)

MACARTHUR BOULEVARD LOOKING EAST FROM EDMUNDS PLACE TOWARD DOWNTOWN. Notice how high above the roadway the houses on the left are, and how many of them sit on top of a stone retaining wall. Several of the streets above MacArthur Boulevard are probably named "terrace" for this reason. Widening the boulevard accentuated the slope in the neighborhood. Notice also the barrenness of the median strip. This photograph is undated. Electric power lines were in place by the 1920s. (NBL.)

UNEVEN ROOFLINES ON THE POTOMAC RIVER SIDE OF MACARTHUR. When Conduit Road was widened, some houses needed to be moved back, and others needed to be raised up. The oral tradition holds that the aqueduct paid each of the homeowners to have the work done, but some chose not to spend the money they received for that purpose. This would explain why the entries of some houses are way below the sidewalk, and why the rooflines are at such different heights. (AS.)

NELLIE AND WARRING BARNES ON THEIR PORCH AT 5134 CONDUIT ROAD. The population increase in Washington in the 1920s necessitated increasing the water supply to the city. So when a new conduit was laid parallel to the old one and on the river side of it, the street above it had to be widened. This picture was taken around 1917, before the new conduit was put in. (NBL.)

NEW CONDUIT ACCOMPANIED BY DISRUPTIONS TO EVERYDAY LIFE. Widening the street required moving the houses on the river side of the street that were already there. Nellie Barnes Livingston, now in her 90s and still living in the Palisades, remembers having to move into a tent when the house was moved. This picture shows the tent on the side of the house. (NBL.)

NELLIE ON A RATTAN SOFA IN APRIL 1923. After the move, an older Nellie Barnes sits on a rattan sofa on a wider Conduit Road. Note the width of the street behind her, the power lines, and the trees on the uphill side of the boulevard. Nellie and her brother attended the Conduit Road School. Their parents were Enoch and May Barnes (see pages 31 and 32 and page 88). (NBL.)

ENOCH BARNES'S HOUSE AT 5134 CONDUIT ROAD AFTER THE MOVE. This striking façade was typical of the Potomac Heights Land Company in its asymmetry, Victorian decorative elements, wide porch, and overhanging eaves. It stood where the Brazilian Naval Commission is today. Note how the land in the background on the right of the picture drops off. (NBL.)

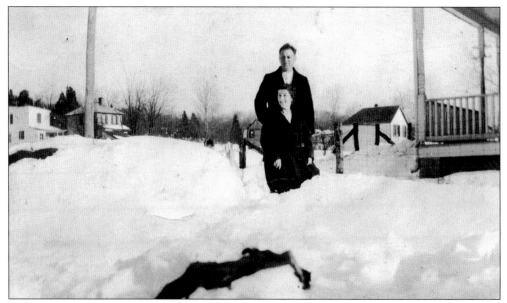

INDIVIDUAL RESIDENTS HELP MAKE A COMMUNITY. The background of this picture shows only a few houses on this section of our main thoroughfare, Conduit Road. But more families settled here, either moving out from in town or from overseas, as did the Elsners, shown here, from Germany. Local residents may have worked downtown or farther out, but their involvement in local issues and institutions are what made the Palisades into a community. (NBL.)

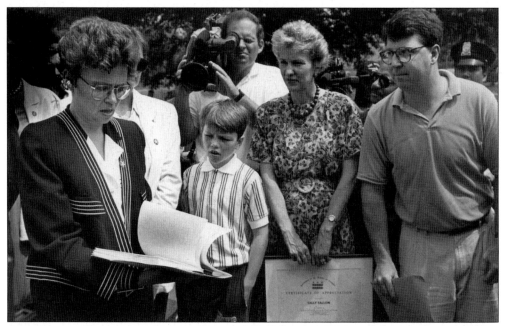

SALLY FALLON HONORED BY MAYOR KELLY. Sally Fallon was PCA president in the early 1990s. Shortly before then, Sally spearheaded the beautification of MacArthur Boulevard, an effort that was recognized by Mayor Sharon Pratt Dixon Kelly. An earlier but less spectacular beautification program award was given by the then-first lady, Lady Bird Johnson, in a 1966 Rose Garden ceremony. (NWC.)

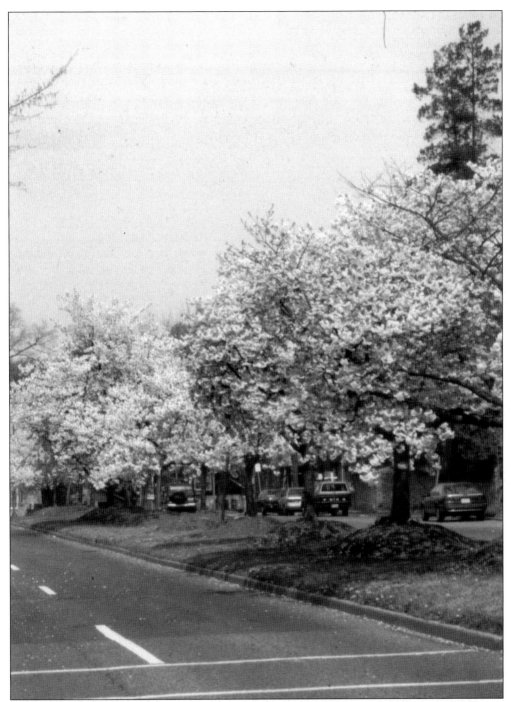

CHERRY BLOSSOMS ON MACARTHUR BOULEVARD. Under Sally Fallon's leadership, 55 Japanese Kwansan cherry trees were planted in the median strip of MacArthur Boulevard between 1991 and 1993. At the outset, only two islands were planted, giving passersbys a preview of what was possible and what was to come. The landscaping was completed in May 1993, and the islands have been maintained by volunteers from the neighborhood ever since. (AS.)

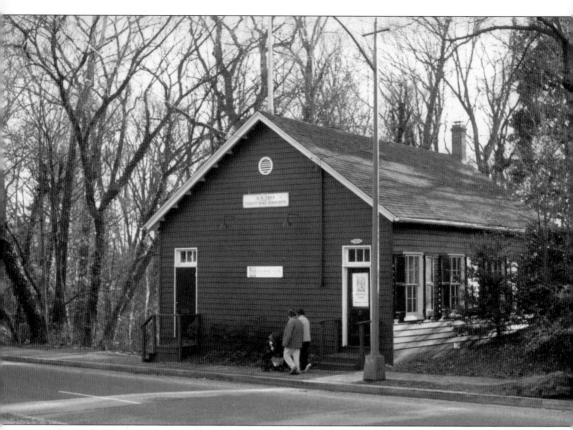

CONDUIT ROAD SCHOOLHOUSE. This building, on the National Register of Historic Places since 1973, has been put to many uses but looks today much as it did originally. It was built in 1864 (and extensively rebuilt after a fire in 1874) as a one-room schoolhouse. It became the Palisades Branch Library in 1928, then the Children's Museum of Washington's French and Spanish Library in 1966. It is now the Discovery Creek Children's Museum. (DWD.)

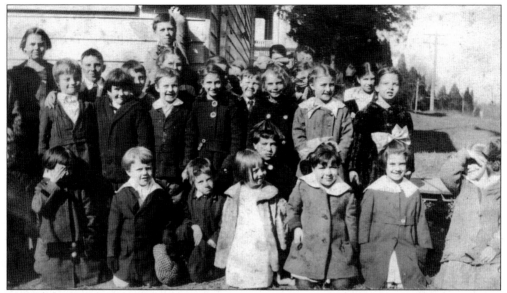

CHILDREN IN FRONT OF CONDUIT ROAD SCHOOLHOUSE, 1915. The school was built to satisfy an 1862 federal law requiring three months of schooling per year for white children in Washington County from first through seventh grades. At that time, the population in this area was scarce. The school's enrollment in 1888 was 64 students. In 1892, there were only 48 desks. The last students to attend school here transferred to Key Elementary School in 1928. (NBL.)

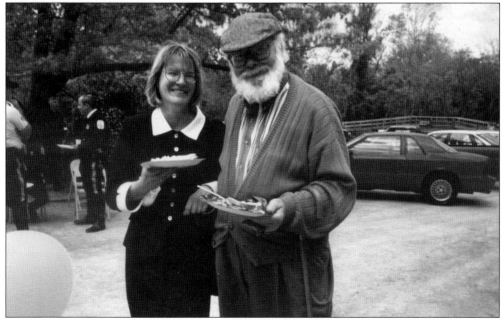

SUE SELIGMANN AND PHIL OGILVIE. A picnic at the Abner Cloud House brought Sue Seligman and Phil Ogilvie together. Sue is the founder and director of the Discovery Creek Children's Museum, an institution that now has after school, weekend, and summer programs for children ages four to 11. Discovery Creek programs emphasize learning about and from the natural world. Phil Ogilvie, who died in 2003, shared with Sue a love of the outdoors and a commitment to education. (CDA.)

"COLORED" SCHOOL AT 2820 CHAIN BRIDGE ROAD, 1923. The school shown here is the second one for African American children at this site. The first, like its counterpart for white children, was also a one-room schoolhouse. It was begun in 1865 and used until this one was completed in 1923. In 1941, black students from this neighborhood transferred to the Wormley School in Georgetown. This building was made into a landmark in 2003. (DWD.)

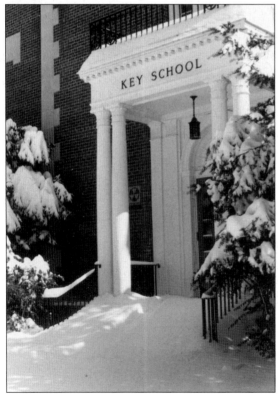

KEY SCHOOL PORTICO ON HURST TERRACE AFTER THE BIG SNOWSTORM IN 1987. The Key School's doors opened to students in 1928–1929. Before that, white students went to the Conduit Road Schoolhouse. Known city-wide as one of the best public elementary schools, Key's teachers have often won awards, and its students score among the top in the city. In the 1940s, suburbanites paid for their children to attend the superior schools in the District. (WES.)

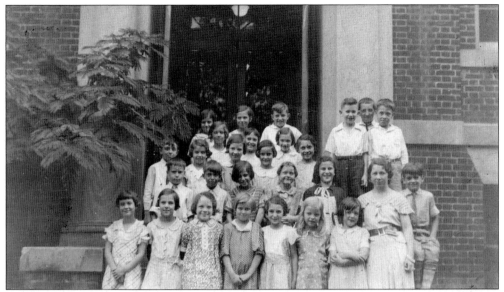

KEY SCHOOL 1932 CLASS PICTURE. When the school opened, it had only 148 students; by 1930, the enrollment was 235. The increase made it necessary to add a second story to the building, which was done in time for the 259 students who arrived in September 1932. The enrollment was down to 180 when the school celebrated its golden jubilee in 1979. Currently the enrollment is approximately 250. (WES.)

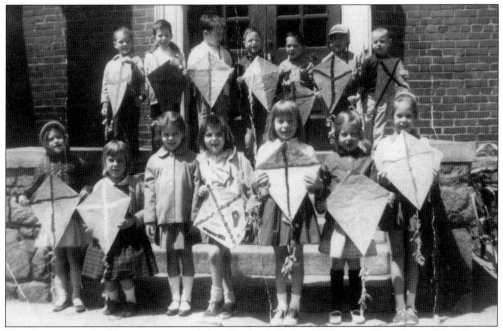

KEY SCHOOL 1963 KINDERGARTEN. This photograph shows what may have been the precursor to Kite Day, which is currently a Pre-K tradition that takes place every spring. On that day, home-made kites are brought to school, and the students and teachers go down to the Rec Center to launch their kites. Although not shown, Mrs. Vivian Scull was the much-beloved teacher of this class. (APC.)

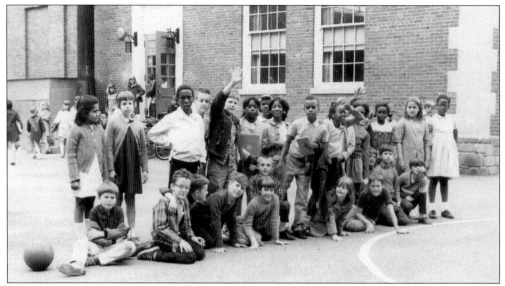

OLD PLAYGROUND AT KEY. In this 1968 photograph, fourth graders are lining up on the old playground, now the site of the new building that was dedicated in 2003. Since Key was under-enrolled, children were brought by bus from Bolling Air Force Base and from other parts of the city, an ongoing program which provides Key with a greater ethnic mix than it would not otherwise have. (JC.)

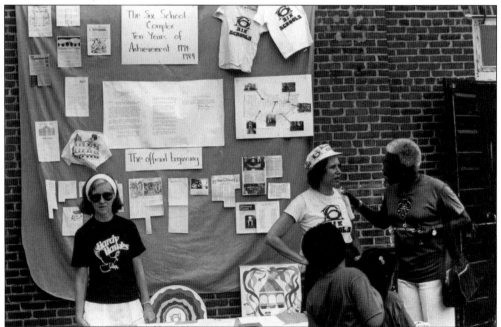

SIX-SCHOOL COMPLEX, 10TH ANNIVERSARY CELEBRATION. Established in 1974 as a result of declining enrollment, the Six-School Complex was a restructuring of six elementary schools into four elementary schools, one middle school, and one arts center. The four elementary schools were Hyde, Key, Mann, and Stoddert. Hardy became a Middle School, and Fillmore became the arts center for the five other schools. Key students still use Fillmore for their music and art classes. (DHD.)

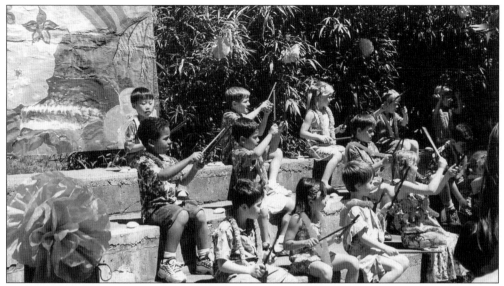

HAWAIIAN FESTIVAL AT THE OLD AMPHITHEATER. The Hawaiian Festival is a tradition at Key that goes back more than two decades. Ivy Caldito, who is from Hawaii herself, initiated the festival, which now involves other teachers and all the Kindergarten and first-grade students. The students learn and perform Hawaiian dances and songs, and they make individual designs similar to those that decorate Hawaiian tapa cloths. (IC.)

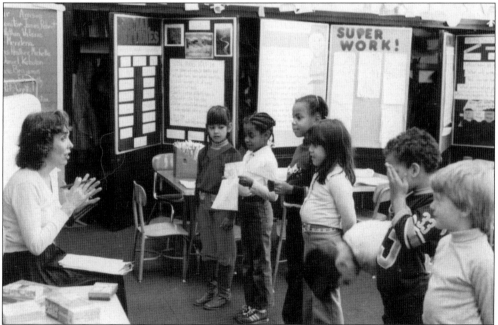

MRS. MCFALL'S CLASSROOM. Frances McFall taught second and third grades and ESL (English as a Second Language) from the early 1980s until a few years before her death in 2003. Her curriculum emphasized nature studies and Japan, especially after her two-year teaching experience in Okinawa. This photograph was taken during the 1982–1983 school year. Harold Gray came to her class once a year for many years to talk to her students about the history of the Palisades. (DHD.)

SCHOOL BOY SAFETY PATROL ON FIELD TRIP. In this 1951 photograph, members of the Key School's Boy Patrol appear to have picked a perfect day for a downtown field trip. They went to participate in the annual citywide School Boy Patrol Parade and to go to a baseball game at Griffith Stadium. In 1953, there were 11 girls and 13 boys in the patrol that was trained by Metropolitan Police Department (MPD) officer Pvt. Joe Anderson. (HG.)

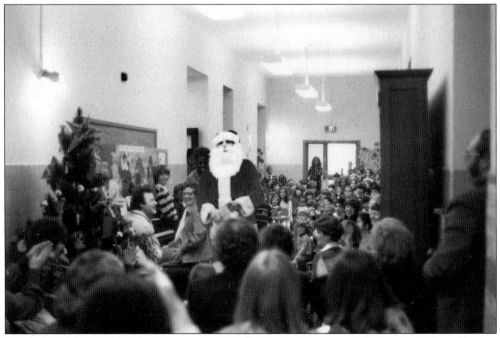

CHRISTMAS ASSEMBLY WITH SANTA AND MRS. STOTTLEMYER AT THE PIANO. Before the new building was added, many of the school's performances, graduations, and assemblies took place either at the Recreation Center and Field House or in a small outdoor amphitheater on the school grounds. Here students are crowded into the second floor hallway of the original school building to welcome Santa and to sing. (WS.)

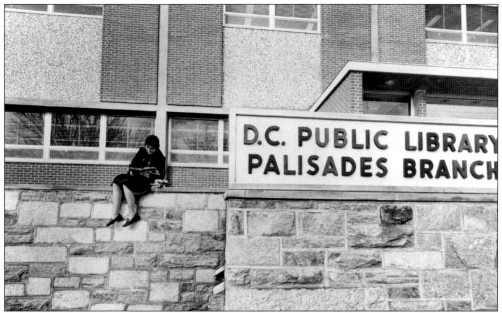

NEW PALISADES LIBRARY. This building was dedicated on November 19, 1964. At that time, the library was open from 9:00 a.m. to 9:00 p.m. Monday through Saturday. The program at the dedication indicated that the library had the capacity for 60,000 books. In 2003, it was estimated that the library had a book stock of about 45,000. Before this building was completed, the public library was in the former Conduit Road Schoolhouse. (PPL.)

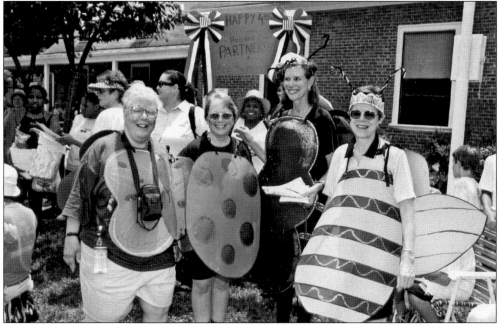

PARADE SPECTATORS ENCHANTED BY PARTICIPATION OF FOUR FRIENDLY BUGS. Palisades librarians (from left to right) Valerie Lebensohn, Deb McLaughlin, Lucy Thrasher, and Elizabeth Courtner dress as bugs for parade to highlight Summer Quest, a program to promote summer reading called "Buggy about Reading." (JJP.)

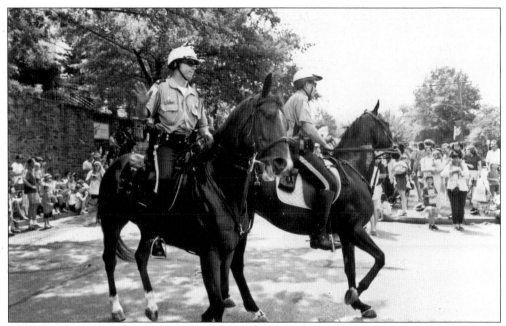

MOUNTED POLICE. Over the years, the Palisades has had a very low crime rate, and police officers work closely with the neighbors to maintain that. Nevertheless Officer William Sigmund, an MPD officer, was killed 1972, and Dr. Michael Halberstam was shot in 1980. Both murders were connected to armed robberies in this neighborhood, and in both cases, the perpetrators were apprehended. This recent photograph shows the police department using horses to direct the parade participants. (JJP.)

BILL SMITH RECEIVES COMMUNITY AWARD FROM MPD. Bill Smith and others persuaded Police Chief Charles Ramsey to order mountain bikes for the whole Metropolitan Police Department. Another Palisades initiative by Smith and the late John Finney was a gift to the police department to purchase a laser gun to apprehend speeding cars. Bill has lived in the Palisades since 1952 and was president of the PCA during the mid-1960s. (PP.)

PENNY PAGANO WITH FIREMAN TOREY HOLMES. Penny initiated Family Night at the Firehouse, and she also received an award from the police. Penny was PCA president from 1996 to 1999 and again for part of 2001. During Penny's tenure, the MacArthur Theater was made into a landmark, and she activated and energized PCA's business committee. Penny represented the Neighborhood Alliance in a formal mediation initiated by the Office of Planning when George Washington University took over Mt. Vernon College. (PP.)

ENGINE 29 VISITS 2002 SUMMER SESSION AT PALISADES COMMUNITY PRESCHOOL. Most of these children below were three years old and had just completed the "Tadpole" (the first) year of preschool in 2002. Pictured are (first row) Keagan Hall, Clara Harrington, Daniel Otteman, Jed Rosenberg, James Shakow, Erik Jensen, Miriam Cantrell, (kneeling, behind children), Agnese Fanizza, Nate Moll, and Ben Shakov; (second row) firefighters Vince Lewis, Thomas Halsey, Lieutenant Wabey, and teacher Edlamar Gomes Torres. (CG.)

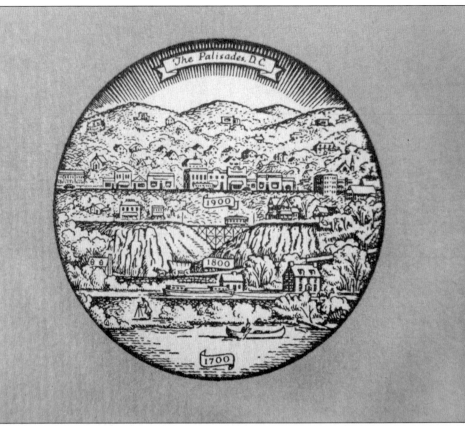

PCA LOGO. Palisades Citizens Association, founded in 1916, was first called the Conduit Road Citizens Association, then the MacArthur Boulevard Citizens Association, and since 1950, the Palisades Citizens Association, or PCA. The seal, drawn by local artist Robert W. Galvin, was made in part to promote the new name of the association. It shows different topographical levels from the river to the heights along what is now Loughboro Road and the corresponding architectural styles and historical developments for each century. As the PCA approaches its 90th anniversary, it is noteworthy that the membership has grown from about 30 to 60 members in the 1930s to over 1,200 families today. In 1950, nearly all of PCA's 1,800 households were members because of a very successful door-to-door canvassing membership drive that was motivated by the presence of Japanese beetles throughout the neighborhood. A coordinated and successful eradication program was undertaken by all of the members. A 1960 newsletter states that PCA had 2,000 members then. PCA is known citywide as being one of the strongest and most effective neighborhood associations. (CUA.)

PALISADES ORCHESTRA. Interest groups are formed and fade away as members have increased or diminished energy to pursue and sustain them. This multi-generational Palisades Orchestra was active at least between 1981 and 1987. While there is no longer a community orchestra, there are a sizeable number of both amateur and professional musicians among our residents. Many of them participated in the 2003 and 2004 Neighbors Through ART concerts (see pages 116 and 117). (NWC, photograph by Robert S. Cutler, 1981.)

PALISADES GARDEN CLUB IN 2005. The Palisades Garden Club was revived by Pres. Elaine Lozier in 1981 after a lapse of many years. Today the Garden Club has approximately 30 members, a majority of whom are master gardeners. They organize monthly meetings and programs that are held at members' houses. Shown here from left to right are Elaine Lozier and Nancy Feldman, a former PCA president in the front row; and Nora Carbine, Margaret Merriman, Helga Schwartz, Maggie Cissel, Maggie Cooke in the second row. (EL.)

DICK ENGLAND CARRIES THE OLYMPIC TORCH PART WAY TOWARD ATLANTA. Richard England was PCA president from 1964 to 1966 at the height of the Civil Rights movement. During his term, PCA voted to withdraw from the all-white Federation of Citizens Associations. Other neighborhood organizations followed and together forced a change in that organization's racially restrictive policy. (RE.)

DR. SHEILA GRAY WALKS THE PARADE ROUTE. Sheila Gray was president of the PCA from 1984 to 1986 and has been the PCA's delegate to the Federation of Civic Associations since 1984. The Federation honored Sheila many times with its Outstanding Senior Delegate and Outstanding Female Delegate awards. She is also the unofficial parliamentarian during the monthly PCA meetings. Previously the parliamentarian was former-senator Abe Murdock of Utah. (PP.)

LYNN SCHOLZ ON A BIKE. PCA president from 1991 to 1992, Lynn has also been the grand master of the Fourth of July parade. In this picture, Lynn displays the T-shirt given her by the United Horsemen's Association, a group that has been part of the parade for more than a decade. Lynn did much of the scanning for this book. She is an architect, writer, and former budget director to the D.C. City Council. (PP.)

MELON CARVERS. Every year, Safeway donates watermelons and cups for the parade, the Palisades-Georgetown Lions Club donates the drinks, and members of the Grand Lodge of D.C., which has been at 5428 MacArthur Boulevard since 1990, cooks over 3,000 hotdogs, rain or shine. These organizations, plus volunteers such as Phil Potter, Jan Fairbank, Stu Ross, Lynn Scholz, Penny Pagano, Carolyn Ortwein, Spence Spencer, and Eliza Button, pictured here from left to right, make the parade possible. (AO and JR.)

KIOSK NEXT TO THE SAFEWAY. Designed by local architect David Mitchell of Design 1, this kiosk keeps the neighborhood informed about community happenings, services, and opportunities. Here a Palisades resident and student from Colombia checks out the kiosk before catching the bus to Georgetown University. David also designed the "Welcome to the Palisades" signs that were placed on the boulevard in May 2005. (AS.)

"COOKIE" PHELPS, U.S. POSTAL SERVICE MAIL CARRIER, AND PALISADES RESIDENT SID LEVY. Our mail carriers and their customers often develop a special bond. Cookie Phelps helped to apprehend a burglar at one house, and she helped rescue another homeowner who was trapped in a thicket. Our post office has become, in effect, an art gallery for local artists, thanks to the efforts of Palisades resident and artist Sheila Rotner. (VCL.)

Ten

VILLAGE ATMOSPHERE SURVIVES DEVELOPMENT PRESSURE

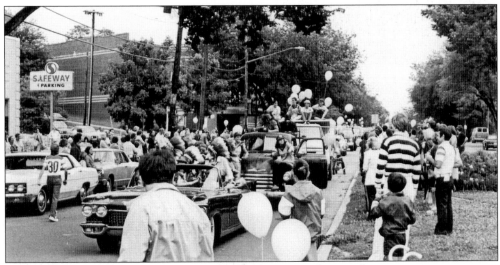

SPECTATORS AT THE PARADE. Some people who are in the parade every year never get to see it. Others cut short or postpone their vacations just to watch! One of the best spots is at the beginning of the route near the Safeway. The parade epitomizes much of what makes the community—coming together, enjoying each other, being out of doors, and being hospitable. The Palisades Citizens Association has run the parade continuously since 1966, but old timers remember a parade in 1961 or even as early as the 1950s. The April 1966 PCA newsletter speaks of reviving the popular event after a two-year hiatus. Between parades, residents do what others do in small towns all across America: they go to work, they go to the movies, they go to church, they paint, they make music, they garden, and they get to know each other. They organize school outings and they reach out to connect with other communities. This chapter contains pictures of the parade and of many other activities. It also presents examples of some of the variety of housing accommodations and of how real-estate developers are once again changing how we look. (NWC, photograph by Kik Lee.)

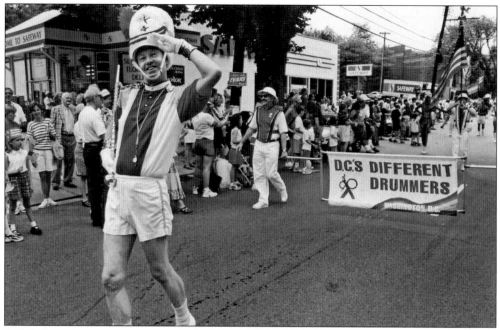

D.C.'s Different Drummers. Now in its 25th year, D.C.'s Different Drummers is a volunteer community music organization made up of gay and lesbian musicians and anyone else who wants to perform in their marching band, swing band, symphony, or classic big band. They have been a popular and important part of the parade for many years. (JJP.)

Washington Scottish Pipe Band. These Scottish bagpipers have been in the D.C. area since 1928 and part of the parade for more than a decade. They wear the MacGregor tartan. Shown at the front of each row from left to right are Greg O'Brien, the pipe-major; Jonathan Ross; drum major Gene Haley (in the front); Bill Mansfield; and pipe sergeant Matt Kuldell. (NWC.)

ASSOCIATION OF THE OLDEST INHABITANTS URGE RE-OPENING OF PENNSYLVANIA AVENUE. The Oldest Inhabitants is among the oldest organizations in town. Its origins go back to the mid-19th century. Their unrelenting, five-plus-year campaign to get Pennsylvania Avenue re-opened to vehicular traffic did not succeed. Here Guy Gwynne of Burleith (far right) and two others carry the banner. Often groups or individuals use the parade as a way of publicizing a cause or an upcoming event. (NWC.)

BATTERY KEMBLE PARK BARKERS. There are always many Palisades dogs with their owners or walkers who gather for the parade behind the Barkers sign. Many dogs wear red or blue bandanas. The walkers usually wear the latest Palisades T-shirt. Here the pack is led by Joey, a Palisades resident, and his gordon setter friend, Remington. (JJP.)

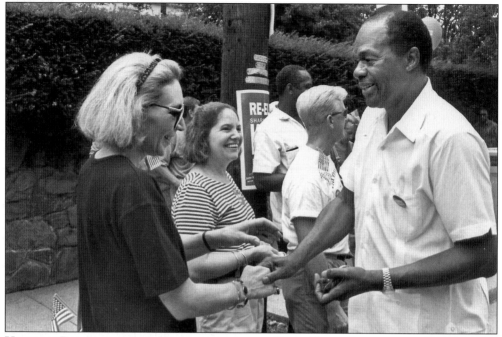

VETERAN POLITICIANS AND NEWCOMERS TO THE FIELD TURN OUT FOR THE PARADE. The parade has been called "the New Hampshire of D.C. politics," in that would-be public figures come out and gauge the public's response the their nascent campaigns. In this undated photograph of perhaps 20 years ago, Janice Oehmann is greeted by Marion Barry, while Alma Gates, currently chair of the local Advisory Neighborhood Commission (ANC), looks on. (NWC.)

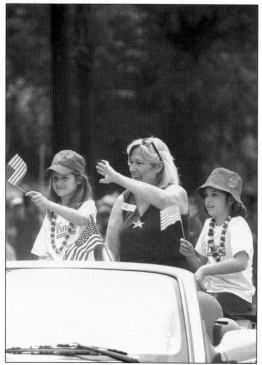

KATHY PATTERSON RIDES THE ROUTE IN 2005 WITH YOUNG ENTHUSIASTS. The current Ward 3 council member, Kathy Patterson, waves to her constituents and friends. Kathy is a former chair of the Judiciary and Government Operations Committees and now chairs the Committee on Education, Libraries, and Recreation. (NWC, photograph by Bill Petros.)

DAVE CLARKE. City council chairman from 1982 to 1990 and again from 1993 until his death in 1997, Dave Clarke rode his old bike all over the city, not just at the parade. He ran for mayor in 1990 and lost to Sharon Pratt Dixon (later Kelly). In this picture, Dave Clarke has just completed the parade route and is heading toward the recreation center for the post-parade festivities. (DTM.)

POLLY SHAKELTON AND SUPPORTERS PEDAL THE ROUTE. The first Ward 3-elected city council member after Home Rule, Polly Shakelton was elected to three terms in 1974, 1978, and 1982. This picture was taken on July 4, 1982, before she won for the third time. She was succeeded by Jim Nathanson and then by Kathy Patterson. (NWC.)

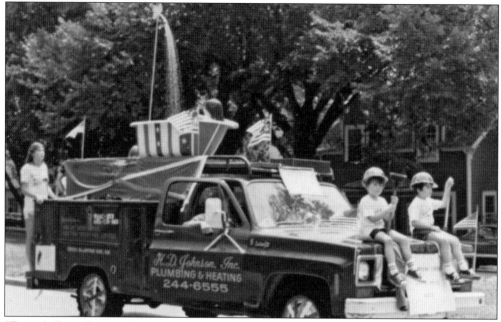

"BETSY'S BATH" ATOP H. D. JOHNSON TRUCK IN 1976. Some plumbing creativity and family ingenuity (a 55-gallon drum of water attached to a sump pump and gas-powered electric generator) was used to transform the H. D. Johnson Plumbing and Heating Chevy pick-up truck into this bicentennial float. Dayle Johnson, then age 13, as Betsy Ross, was the bather. Water showered on her as she was driven the length of the parade route. (MHM.)

FOUR GENERATIONS OF H. D. JOHNSONS PHOTOGRAPHED IN 1992. The Johnson family business has been in the area since 1934. Pictured here from left to right are Harold D. Johnson Sr. ("H. D."), Jr. ("Dave"), III ("David"), and IV ("Little Dave"). H. D. Johnson Sr. was born in 1911 and was the original plumber for Foxhall Village. His grandson remembers hearing H. D. Sr. relate that when he was a child, Henry Foxall's farm was still farmland. (PMJ and HDJ, photograph by Liz Johnson.)

Tommye Lee Grant, Mistress of Ceremonies, with Her Family. At the end of every parade, the participants gather at the recreation center and are given prizes in various categories. For many years, the Grant family, residents of the Palisades since 1983, were the judges, and Tommye was the master of ceremonies. Pictured here are Tommye, with twins Tracy and Trisha, and their father, Milton Grant. (JJP.)

Above left: **Hillcrest Partnership Co-Founder Miles Steele III Addresses the Crowd.** Ever since the partnership between Hillcrest and the Palisades was founded, Hillcrest residents have come from Ward 7 across town to be in the parade. Here Miles is at the microphone, while Erik Gaull, former PCA president, and Carolyn Lynch, smile having just completed the parade. (JJP.) *Above right:* **Marion Mack and Erin Myers.** At the end of the parade, reunions between friends take place on the grounds in front of the field house. Here Marion Mack, in costume, and Erin Myers, lifetime Palisades resident and Key School graduate, greet each other with affection. (DTM.)

HALLOWEEN AT BARBARA'S MONTESSORI SCHOOL ON HURST TERRACE. Native Washingtonian Barbara Allan started her school in 1984. Since then, she has taught approximately 1,000 children between the ages of two and four. Her students today include many "walkers," as more young families have moved into the neighborhood. Included here are Susie Canton (standing at left), Avery Borgmann (the pumpkin), Barbara Allan (standing, center), Amelia Steinberg, Daniela Rauch (Superman), William Van Arsdall, and Kate Green (seated). (BA.)

RIVER SCHOOL AMONG NEWEST OF AREA PRIVATE SCHOOLS. On the former site of the Georgetown Day High School and St. John's Development Center, the River School opened here with 10 children in 2000. They now have approximately 170 students, of whom 10–15 percent are deaf or hard of hearing. Here Kate Koffman and Carolyn Nordberg (standing on the right, holding baby) are picking up their children Aidan Banerjee and Charlotte Nordberg. (AS.)

SALLY SMITH, FOUNDER AND DIRECTOR OF THE LAB SCHOOL OF WASHINGTON. A K–12 day school, The Lab School is located at 4759 Reservoir Road in the former residence of developer Jacob Clark. The campus today is enhanced by brightly colored murals and sculptures reflecting the emphasis that the school places on the arts. Founded in 1967 for learning-disabled children, the school earned the distinction of being named a "Blue Ribbon" school in 1996–1997 for the lower school and in 1997–1998 for the high school. (NWC.)

ST. PATRICK'S EPISCOPAL DAY SCHOOL DEDICATES NEW PLAYGROUND IN 2004. Founded in 1956, the school now has approximately 480 students from nursery through eighth grade. The main campus is next to St. Patrick's Episcopal Church on Whitehaven Parkway. The school extended its academic program in 2002, with the purchase of and renovations to 4925 MacArthur Boulevard (see page 69), and it is currently considering adding a high school. (SPS.)

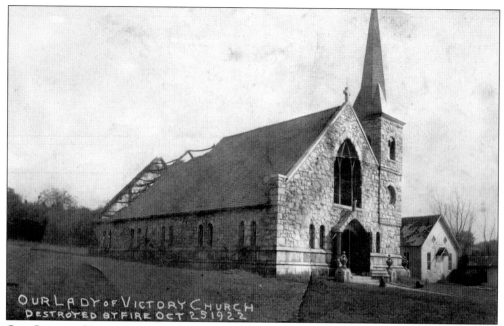

OUR LADY OF VICTORY CHURCH
DESTROYED BY FIRE OCT 25 1922

OUR LADY OF VICTORY AFTER THE 1922 FIRE. The first mass of this parish was celebrated in 1908 across the street from the present church in a private home where Parker's Exxon is now located. That same year, Father Malechai Yingling applied for a building permit for a church, listing himself both as owner of the property and architect of the proposed building. That structure was partially burned in 1922. (DWD.)

DETAIL ON THE MACARTHUR BOULEVARD SIDE OF OUR LADY OF VICTORY. Our Lady of Victory added a rectory in 1936 and the Our Lady of Victory School in 1955. The School, run by the Sisters of Notre Dame, whose convent has been used as the library since the sisters left in 1990, was at first just for first through fourth graders. The coeducational school now has students from age three through eighth grade. (JN.)

ST. DAVID'S EPISCOPAL CHURCH ON CONDUIT ROAD. St. David's celebrated its centennial in 1999. It was originally a mission church of St. Albans, named for the patron saint of Wales. By 1927, the church shown in this photograph was located on the uphill side of Conduit Road just east of Chain Bridge Road. The parish left this site in 1939, and services were held temporarily in the Palisades Field House. (NBL.)

ST. DAVID'S EPISCOPAL CHURCH AT 5150 MACOMB STREET. The cornerstone for this church was laid on October 6, 1940; the building was consecrated in 1941, enlarged in 1957, and renovated in 2001. St. David's became its own parish in 1949. Today it offers three Sunday services, Christian education for all ages, and outreach programs. Many concerts, exercise classes, and meetings are held there. (DWD.)

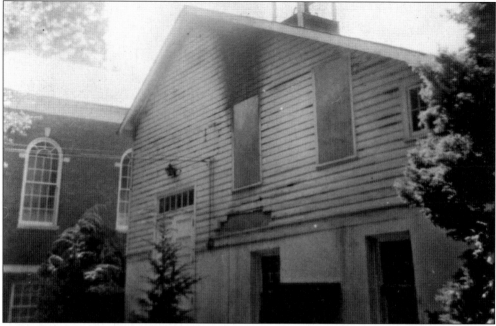

1957 FIRE DAMAGED FORMER PALISADES COMMUNITY CHURCH. Originally called the Potomac Heights Community Church, its founding members come from 11 different denominations. The church grew out of a non-denominational Sunday school that began in January 1923. During the 1957 fire, about half of the church's historical records were lost. The background here shows the exterior of today's church, dedicated on January 22, 1939. (AD.)

SANCTUARY OF TODAY'S PALISADES COMMUNITY CHURCH AT 5204 CATHEDRAL AVENUE. Nelson C. Pierce, minister from 1952 to 1967, is shown here officiating at the May 28, 1960, wedding of Chester and Thelma Gray. Chester is Harold Gray's oldest son. Nelson Pierce was known beyond this church's parish for the series of radio and television talks that he gave beginning in 1958. (HG.)

PREPARATIONS FOR BIANNUAL HAM AND OYSTER DINNER. Here members Johnny Mack and Roland Stottlemyer prepare for a ham and oyster dinner, a popular neighborhood event. The church has provided space for PCA board and ANC meetings, for Neighbors Through ART music auditions, and for a community synagogue for Saturday services. It accommodates the Washington Society of Jungian Psychology, which sponsors lectures and workshops in the church. (WS.)

CLASSES AT THE PALISADES COMMUNITY CHURCH. The education wing, named for Nelson C. Pierce, was completed in 1959. Palisades Community Church (PCC) sponsors Community Preschool of the Palisades, which was founded by PCC in 1986. Over the years, Sunday school classes, a teen club, a youth choir, instrumental music studies, and scouting have carried out the original founders' mission to nurture the children of the neighborhood. (PCC.)

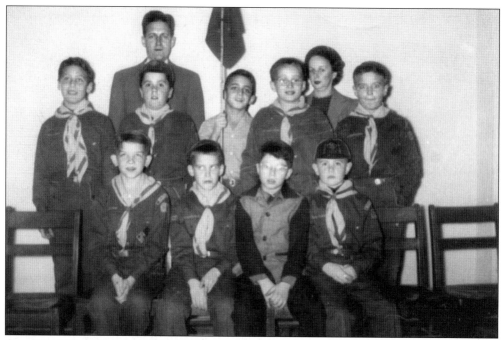

CUB DEN WITH HAROLD AND LIDA GRAY AS THE DEN PARENTS, 1949 (ABOVE); BOY SCOUT TROOP 61 INCLUDING MR. TORNE, PASTOR JEFF NEWHALL, AND SCOUT LEADER JOHNNY MACK, 1981 (BELOW). The PCC has sponsored and supported the Scouts since 1933. Today there is a room in the church where the boys meet. In it is a display of arrowheads that were excavated by a former Potomac Avenue resident of the Palisades. Johnny Mack was scoutmaster of Troop 61 from 1943 until his death in 2000. In a memorial tribute to Mack, Harold Gray wrote that his "influence on 'his boys' caused them to lead constructive adult lives." (HG, JC.)

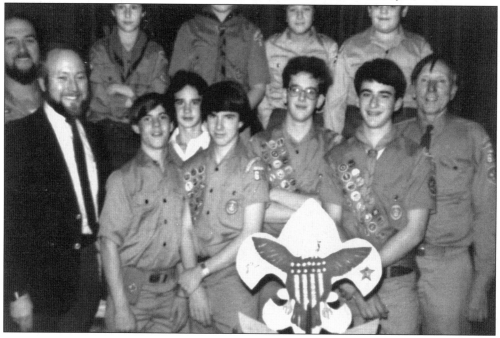

IDA SILVER MARIEN (1913–2002).
Ida Silver was born in Rochester, New York, the oldest of 10 children. She moved to Washington during the Depression. She and her husband lived at 5420 Sherier Place and were active in the Palisades after 1935. Ida founded a preschool and worked at the Florence Crittenden Home during the 1950s and 1960s. As this book goes to press, their house was moved to the back of the lot to make room for a larger residence. The Marien House will become a garage. (Photograph courtesy of RB and LS.)

HENRY MARIEN (1897–1983).
Henry Marien rescued Ida during a boating accident while they were courting. Henry was a self-taught scholar, philosopher, naturalist, gardener, actor, cook, and pianist. He and Ida raised two children. This 1978 portrait is by Palisades artist Virginia Clark Levy. (VCL.)

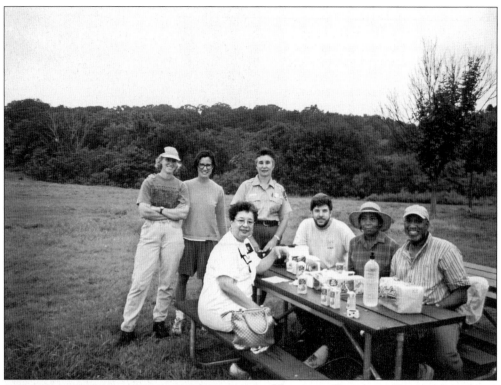

HILLCREST-PALISADES COMMUNITY SERVICE DAY. Founded in 1997, the Palisades-Hillcrest partnership initially organized a number of "green" events including an Arboretum tour and this tree-planting/park maintenance event. Shown here at Kenilworth Park from left to right are Cary Ridder (a former PCA president), Beth Solomon, Gloria Logan, Susan Rudy of the National Park Service, unidentified, Mary Hammond, and Miles Steele. (AS.)

MYRNA AND RAYMOND FITZGERALD TALK WITH DON MURRAY. The 2004 partnership event included a panel of individuals from the two communities who recounted their experiences during school desegregation in Washington. Myrna Fitzgerald, one of the panelists, grew up in the Palisades neighborhood and still has family here. Don Murray (left), from Hillcrest, chaired the panel. (JRW.)

KEY SCHOOL FIFTH-GRADER TAMARA AZOURY READS HER DREAM SPEECH.
As part of the 50th anniversary of *Brown v. Board of Education*, all the members of one fifth-grade class in each neighborhood wrote and illustrated speeches expressing their personal dreams for the future. Participating students were from Jackie Edwards's class at Anne Beers Elementary School in Hillcrest and from Christine Lonergan's class at the Key School. (JRW.)

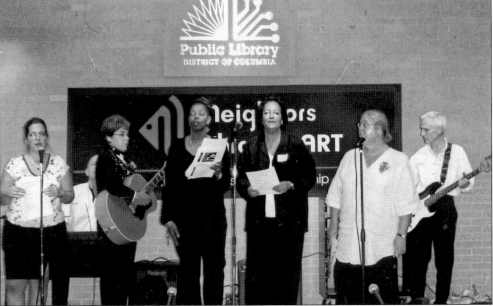

NEIGHBORS THROUGH ART GOSPEL CHOIR AND BAND PERFORM AT MARTIN LUTHER KING JR. MEMORIAL LIBRARY. In 2003, Palisades and Hillcrest musicians came together to perform pop and classical music, show tunes, folk songs, and Handel's *Hallelujah Chorus*. In 2004, a smaller group of musicians performed civil-rights songs. Shown here are Penny Percey, Nelson Smith (at the keyboard), Maryann Krayer, Andrea Grant, Linda Jackson, Kathleen Corbett, and Mark Grummer. (JRW.)

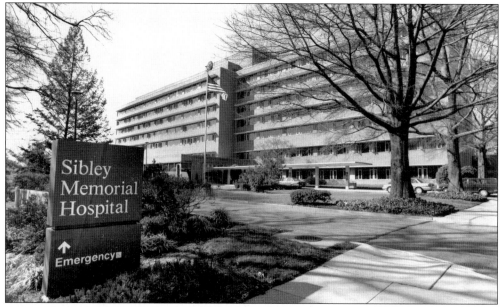

SIBLEY HOSPITAL. Since 1961, when Sibley opened its doors at its present site, many Palisades residents have used it for their medical needs. Many residents volunteer their time. Before 1961, Sibley was located at North Capitol and M Streets, but its origins go back to the 1890s. Since 1961, Sibley has added outpatient services, an emergency department, an assisted living facility, and a nursing facility. (NWC, photograph by Bjorn O. Schroeder.)

MACARTHUR THEATER. This movie theater was in use from December 1946 through March 1997. Designed by John J. Zink as a single, 1,000-seat theater, it was triplexed in 1982. Before that time, British films were often shown there, and they also had special films for children on the weekends. The theater, with its distinctive art moderne aluminum streamlined marquee, was made into a landmark in 1997 and is now a CVS drugstore. (CUA.)

RESIDENCE OF GERMAN AMBASSADOR. The land on which this dramatic residence is located was probably once part of Foxall's Spring Hill Farm. It was also at one time the site of the Uplands estate, and during the Civil War of Battery Cameron. Over the years, "Daisy" Harriman, Pearl Mesta, Thomas Fortune Ryan, and President Eisenhower's Secretary of Treasury George M. Humphrey, have lived here. It was purchased by the German government after World War II with the help of the United States. (AS.)

ART DECO HOUSE ON UNIVERSITY TERRACE. This 1949 house was built by then-owner William Nixon, a member of the art department at Dunbar High School. It was designed by Howard D. Woodson, a renowned African American civic leader and structural engineer. The Nixons were among several black families who moved into this area in the 1940s. Ownership of the land near Battery Kemble has been racially mixed since the Civil War. (AS.)

AMBERGER FARMHOUSE AT 5239 SHERIER. The Amberger family owned much land and had built many houses in the area by the early 20th century. Although no building permit can be found to pinpoint exactly the age of the building, Harold Gray wrote in the 1950s that it was already 100 years old then. The porch was not part of the original building. (AS.)

3000 UNIVERSITY TERRACE. Built perhaps around 1890 and known as Longview, this house was situated on a hill at the upper end of University Terrace, and it commanded a view of the Potomac. Demolished in the fall of 2003, the site is vacant as this book goes to press. The recently enacted University Terrace/Chain Bridge Road Tree and Slope Overlay will give some protection to the trees on this site if it is enforced. (AS.)

BENDING LANE. This early example of infilling was designed by architect Grosvener Chapman c. 1970. The houses on one side of Bending Lane back up to the trolley right-of-way, giving them deep back yards. They were designed so the large picture windows in the living rooms look out onto the natural beauty. Chapman's daughter and her family lived here until a few years ago. (JN.)

DANA PLACE CONDOMINIUM. Designed by architect Roger Lewis in 1972 as a housing cooperative, this innovative cluster of homes is another early example of infill development. The seven houses on a mere 39,000 feet (just under an acre) are set into a sloping terrain. Shown here are Roger Lewis; Hannah Mazer; Kevin, being held by Eleanor Lewis; David (in the stroller), Sondra (kneeling), and Bill Bechhoefer; and Michael Mazer. The Lewis family still lives here. (MHM.)

ORIGINAL SHERIER HOUSE AT 5066 MACARTHUR BOULEVARD. This house is said to be the original 1820s Sherier farmhouse. It was at first located on the other side of Conduit Road. When it was moved, it got a new foundation and a new front addition, giving it a new appearance. The horizontal timbers inside the old part of the house show notching and appear to have been part of an older barn, an example of early-19th-century recycling of building materials. (AS.)

CATHEDRAL AVENUE NEIGHBORS. Many developers are building houses that dwarf their pre-existing neighbors, as seen here. The disproportionate size of the new structures have resulted in zoning battles and litigation. The vegetation between the two houses here serves as a useful buffer in the absence of more compatible development in terms of scale. (AS.)

THE "SWAN HOUSE" ON POTOMAC AVENUE NEAR NORTON STREET. Built as a simple rectangular mass, the porch and turret were added when this house was remodeled. The effect is very different from 5066 MacArthur on the previous page but illustrates how an addition can add space and change the character of a house, and how remodeling (the alternative to tearing it down) can often "turn an ugly duckling into a swan!" (AS.)

THE "TREE HOUSE" ON POTOMAC AVENUE NEAR MANNING PLACE. Designed by Aaron Green, a protégé of Frank Lloyd Wright, this house is so well designed and camouflaged as to appear to be almost part of the woods that surround it. A real-estate promotional piece from long ago says that from its upper floor you can see the Potomac River, but as the trees have matured, that view has been cut off. (AS.)

THE CANOPY OF STREET TREES AT GALENA BELOW SHERIER. Galena Street is one of many streets that still has a full cathedral-like canopy of trees in the Palisades. On many other streets, the trees have had holes cut into their crowns to accommodate the overhead electric wires, making the trees look like doughnuts. (AS.)

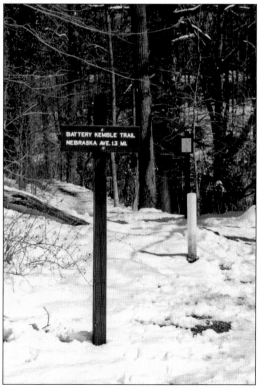

BATTERY KEMBLE TRAIL SIGN. The trails through Battery Kemble Park traverse some of the most unspoiled scenery in this neighborhood. Operated by the National Park Service, the trails are well marked and maintained, and they are enjoyed by residents in all seasons of the year. (LS.)

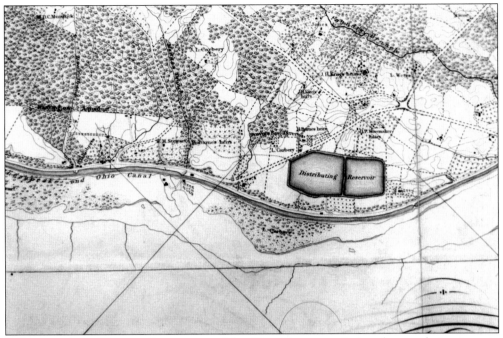

PALISADES AREA HEAVILY FORESTED IN MID-19TH CENTURY. Before the population jump in D.C. during the Civil War, when this area was still very sparsely populated, most of the area was covered by forest. Today some of oldest trees in the city are said to be the tulip poplars, remnants of that old forest, in the woods next to the Old Conduit Road Schoolhouse. (LC # CW0678-1.)

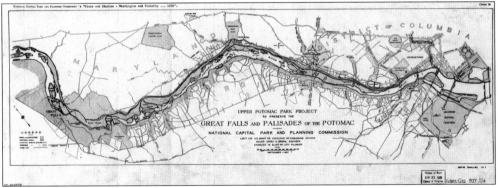

PLAN FOR POTOMAC RIVER REGION PARKS, 1927. One of the mandates of the National Capital Planning Commission is to preserve green spaces in the city. As can be seen from this 1927 map, much of the Potomac River Valley was planned as parkland. Although Washingtonians often chafe at being under federal jurisdiction, it may be that the environmental protections of the federal government will ultimately provide the strongest protections for the urban forest. (LC #G3851.G52/1927.U4.)

SOURCES

Extensive use has been made of published sources, and I have benefited from the generosity and expertise of many individuals. It is my intention to offer footnotes on the Palisades Web site (www.palisadesdc.org) giving additional information about the Palisades and the sources on which I relied while writing these captions. Interested readers may download these footnotes at any time. Please feel free to contact me at palisadesdc@hotmail.com and put "alice history" in the subject line.

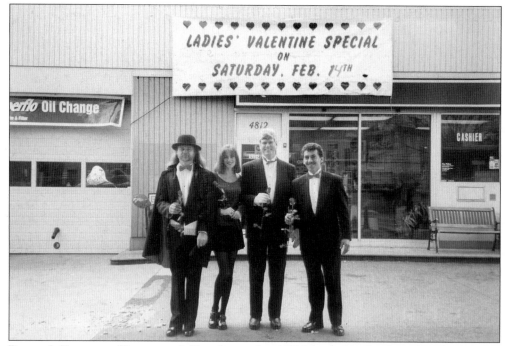

PARKER'S EXXON ON VALENTINE'S DAY. Located at 4812 MacArthur Boulevard, Parker's Exxon is on the site of where the first service of Our Lady of Victory was held. In recent years, proprietor Lynn Cook has established a new Valentine's Day tradition: the attendants dress in formal attire and hand out roses to female customers. Shown here are Russell Doten, Jennifer Cook Richards, Lynn Cook, and Jose Villalobos. (JJP.)